A–Z
OF
FROME
PLACES - PEOPLE - HISTORY

Mick Davis & David Lassman

AMBERLEY

To my wife Lorraine with thanks for all her support – M.D.

For my son Michael J. Lassman and his favourite toy, Spiderman – D.L.

First published 2021

Amberley Publishing
The Hill, Stroud, Gloucestershire, GL5 4EP
www.amberley-books.com

Copyright © Mick Davis & David Lassman, 2021

The right of Mick Davis & David Lassman to be
identified as the Authors of this work has been
asserted in accordance with the Copyrights,
Designs and Patents Act 1988.

ISBN 978 1 3981 0346 7 (print)
ISBN 978 1 3981 0347 4 (ebook)

British Library Cataloguing in Publication Data.
A catalogue record for this book is available
from the British Library.

Typesetting by SJmagic DESIGN SERVICES,
India. Printed in Great Britain.

Contents

Introduction	5	Garston Lodge	42
		Gentle Street	43
Achilles	6	Gimblett, Harold	44
Aldhelm	7	Glanvill, Joseph	44
Apple Alley	7	Gorehedge	45
Athelstan	8	Great Fire of	
		Cheap Street	46
Baker, Benjamin	9		
Bath Street	10	Heritage Trail	48
Bennett, Vicar	12		
Blue House	13	Independent Market	49
Bookshops	14	Iron Gates	50
Breweries	15		
Bridges	16	Justice Lane	51
Bunn, Thomas	18		
Burne-Jones Windows	19	Ken, Bishop	52
Butler & Tanner	20	Keyford	53
Cafés	22	Lamb & Fountain	56
Catherine Hill	23	Literary Frome	57
Cheap Street	24	Local Historians	58
Cheese & Grain	25	Lock-ups	60
Cheese Show	26	Loos	62
Cinema	27		
Cockey's	28	Market Place	63
		Memorial Theatre	64
Dancing Bear	30	Monmouth Rebellion	65
Deadly Is the Female	31	Montgomery,	
Druid Stones	32	Field Marshall	66
		Museum	67
Eadred (Edred)	34		
Ecos	34	North Hill House	69
Eels Feet (Pickled)	35		
Election of 1832	35	Oatley, Sir Charles (1904–96)	70
Frome Festival	38	Police Station	71
Fromefield Barrow	39	Pubs	72
Frome Hoard	40		
Frome Society for Local Study	41	Quakers	74

Railway Station	76	Valentine Lamp	89	
Rook Lane Chapel	77	Vinegar Works	89	
Rook Lane House	78			
Round Tower	79	Woollen Cloth Industry	91	
		Workhouse	91	
SHARE: A Library of Things	80			
Singer's	81	Xmas Lights 2013	93	
Town Hall	83	Yerbury Family	94	
Trinity Slum Clearances	84			
Tunnels	86	Zion Chapel	95	
UFOs	87			
Unicorn	88			

Introduction

In 1993, the *Daily Mail* ran a double-page spread on Frome entitled 'Death of the Rural Dream', in which it described a town in the grip of vandalism, unemployment, drug-taking and drunken yobs, and a place where it was definitely not safe to venture out during the hours of darkness. By 1999, with the opening of nearby Babington House, this began to change, although not everything on the town's road to 'cool' can be laid at the door of this neighbouring celebrity hang-out. The town's physical attractions were also starting to be noticed – with approximately 350 listed buildings, this is more than anywhere else in Somerset – and its low property prices were attracting a wave of new money from the east. People like Ivan Massow, the director of the Institute of Contemporary Arts, bought and restored one of the town's Georgian mansions and so gradually the town was on its way to becoming the feted Frome we know today.

The name Frome comes from the Old British word *ffraw*, meaning fair, fine or brisk, a word used to describe the flow of the river. The name was first recorded in 701 when Pope Sergius gave permission to Bishop Aldhelm to establish a monastery here, and the town grew rich from the cloth trade with its many mills taking advantage of the meandering flow of water. Nothing lasts forever though, and the wool trade declined due to the town's inability to compete with manufacturers up north and abroad. It still had its market and other industries sprang up to take advantage of the workforce, but eventually these moved elsewhere or closed, which led to the situation of the 1990s.

Today the revived Frome is a centre for arts and culture, and even though it may still be seen by many as merely a satellite town for Bath and Bristol, the town has gained numerous accolades, including being voted the best place to live in the South West by the *Sunday Times* in 2018.

Despite the seeming inclusivity of the book's title, this is not an all-encompassing guide to Frome. Any such book would have been many, many times the size of this volume and even then, could probably not do justice to the town's incredibly rich and illustrious historical heritage. What does reside between this tome's own alpha and omega is an eclectic mixture of entries that attempts to shine light on many of the town's aspects which are either rare or unique, along with several of the attractions that the authors feel make Frome the place it is today.

Where we have not paid much attention to certain histories – local churches for example – or excluded other subject areas, this is because we believe they are adequately covered within the plethora of other books on the town's history (a great number of which we have mentioned in the text or bibliography), preferring instead to concentrate upon the lesser-known and more unusual facets connected with the town.

Mick Davis & David Lassman, April 2020

A

Achilles

The Achilles motor car was made, or at least most of its component parts were assembled, in Frome by Thompson & Co. at Keyford & Butts Hill from 1901 to 1908. It was available in several versions, from 6 up to 12 horsepower and prices ranging from £145 to £300, the latter for the four-seater Tonneau shown here. One advertisement claimed the 8hp version climbed the steep Westerham Test Hill, in Kent, in 6.1 minutes, which may have been impressive back then, but not when compared with the new Mercedes-AMG GT 63 S 4matic that apparently goes from 0–60 in 3 seconds – but everything has to start somewhere. The first garage in the town was Hobbs & Sons, next to the Victoria Inn (now Frome 'n' Groom) in Christchurch Street East, which began trading from around 1906. In more recent times, a 1908 version of this car regularly took part in the annual London–Brighton runs.

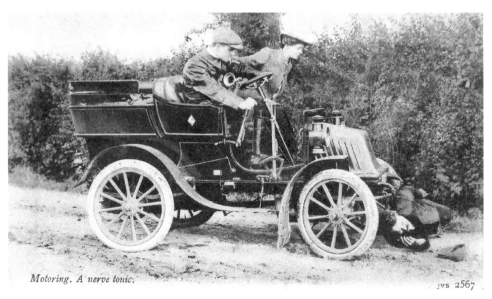

Motoring. A nerve tonic.

jws 2567

A local meets an early motorist *c.* 1902.

Aldhelm

Saint Aldhelm, as he became known after his death, was the Abbot of Malmesbury, Bishop of Sherborne and founder of several churches, including ones at Bradford-on-Avon, Bruton and Frome. Bede referred to him as being 'a man most learned in all respects, for he had a clean style and was wonderful for ecclesiastical and liberal erudition'. He is said to have established a religious settlement and church, dedicated to St John the Baptist, near the great Forest of Selwood in 685, and it is from this year that the town of Frome dates its foundation.

Aldhelm was born around 639 at his family estate in Wareham, Dorset, and was possibly related to Ine, king of Wessex. He studied under the great Irish scholar Maidulf, at Malmesbury, and after the latter's death, succeeded him as Abbot. The 'official' story of Frome's founding is that this 'good and saintly man' was resting on the banks of the River Frome, on his way from Malmesbury to Sherborne, when he heard tales of bands of outlaws and robbers that lived in the great wood nearby. These he charmed out of the forest by singing songs, while accompanying himself on the harp! He was an exponent of Roman rather than Celtic Christianity and wrote a 'notable book' against the error of celebrating Easter at the wrong time. The truth has probably more to do with the complex political situation and rivalry of Christian groups competing for power and influence in the area.

Aldhelm died at Doulting, near Shepton Mallet, in 705 and his body was brought back to Malmesbury. The funeral cortege halted every 7 miles, including Frome, and a stone cross was erected at each stopping place along the route. According to William of Malmesbury, writing five centuries after Aldhelm's death, his buildings in Frome were still standing in 1125 but their precise location is not known, and nothing remains today.

The present-day St John's Church is reputedly built on the original site of Aldhelm's church and contains two sculptured pieces of stone – allegedly part of the Saxon cross erected at Frome – which are built into the wall of its tower. For further reading on the town's founder see Peter Belham's *Saint Aldhelm and the Founding of Frome* and *Saint Aldhelm: Abbot of Frome* by H. M. Porter.

Apple Alley

Now home to the town's pigeon community and an assemblage of dustbins, this passageway gives an idea of what medieval Frome would have looked like, with its jettied sixteenth-century buildings – a consequence of a floor tax – and limestone-slabbed crazy paving. If you have not yet had the pleasure, it is worth a visit and runs parallel to Cheap Street, which is above, and King Street below.

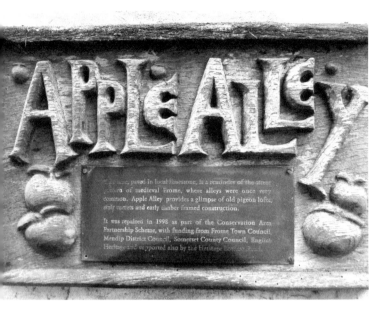

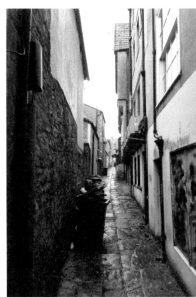

Above left: Apple Alley restoration of 1998.

Above right: *Left*: Apple Alley in 2020.

Athelstan

At first glance there might seem little to connect Frome with Athelstan, Saxon King of England between 924 and 939, but the reality may well have had seismic ramifications for the town. By the time this grandson of Alfred the Great came to the throne, unification of the various kingdoms under the authority of one leader, had almost been completed. With Athelstan's conquest of Northumbria in 927, he could revel in the title of 'Rex Anglorum: King of the English'. But this was not enough for this ambitious Saxon and throughout the next seven years he sought to bring the Welsh and Scots under his rule, as well. This he achieved in 934, with the defeat of Constantin, the Scottish king. To seal the deal, a charter was signed that year, meaning that Athelstan could call himself 'Rex Totius Britanniae' – 'the king of the whole of Britain' – and if you haven't guessed where that historic charter was signed, perhaps you shouldn't be reading a book about Frome.

B

Baker, Benjamin

Benjamin Baker, one of Frome's illustrious sons and an engineer of huge renown, was born at Butts Hill in 1840. During his professional career he was involved in the construction of London's Metropolitan Railway and was called as an expert witness in the Tay Bridge disaster enquiry of 1879, an incident in which high winds caused the bridge's collapse and the deaths of seventy-five people on the train travelling across it. He was also responsible for the design of the cylindrical vessel in which Cleopatra's Needle, located on the Thames Embankment, was brought over to England from Egypt in the late 1870s. His biggest and most famous achievement, however, was the design and engineering of the Forth Bridge across the Firth of Forth in East Scotland, along with Sir John Fowler, which began in 1882. Although never intended to be a

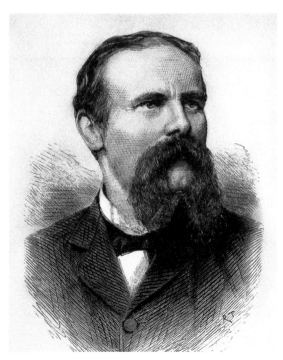

Sir Benjamin Baker 1840–1907.

thing of beauty, his design worked, and it is still the second longest single-cantilever bridge span in the world. A plaque erected by Frome Society for Local Study marks the place of his birth in the town.

Bath Street

Strange as it may seem today, there was a time – before 1812 – when Bath Street did not exist and the main way out of Frome's Market Place was up Stony Street and then either left along Palmer Street and into Rook Lane (or further along to Gentle Street) or right, up Catherine Hill, all of which had narrow, dark and badly maintained roads.

A prime mover behind this improvement to the town's layout was **Thomas Bunn**, who had visions of transforming Frome, through sweeping Georgian terraces, into a fashionable imitation of Bath. His description of the area to be cleared perhaps says it all:

> I have counted three dung hills from one spot in a principal thoroughfare. In the very centre of town near the Market Place, and principally in a place called Anchor Barton, was such an accumulation of dung hills, slaughter-houses and tallow melting houses as is indescribable. The principle thoroughfares were narrow lanes. That I might

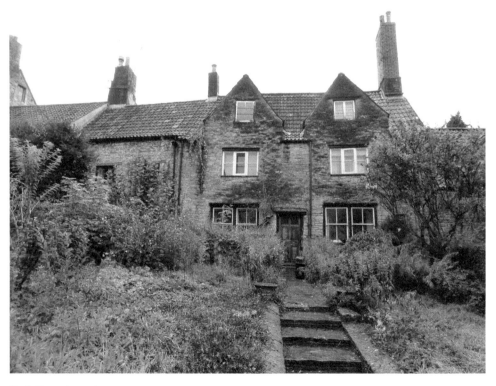

Bath Street's ancient cottages.

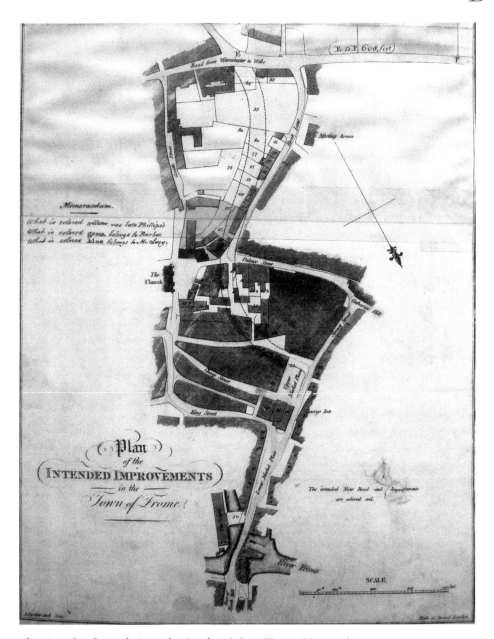

The 1810 plan for Bath Street by Crocker & Son. (Frome Museum)

not mistake, I have measured some of them which remain. In the wider parts they are, including two footways, about 16 feet 7 inches; in the narrower parts 13 feet and 11 feet 10 inches.

The new road – named after Lord Bath, who owned the land and not after the city Bunn was attempting to imitate – involved the demolition of the slums, an area

dominated by the Anchor Inn, standing partly where No. 4 Bath Street is now. This is the one with the Ionic columns at the front, which date from 1836. Amongst the structures erected alongside the road was the impressive Gothic screen, which leads into the area in front of St John's Church. Between this and the church was another slum complete with a jumble of decaying buildings, including a pub called the Bell that stood almost next to the church door; all were demolished to make way for the road and give a more imposing view of the church.

Still impressive today and little altered, apart from its many shopfronts, Bath Street has several fine buildings near the bottom end and is well worth a stroll on a sunny afternoon. Further up the road is **Rook Lane Chapel** and several ancient cottages dating from the time of the original Rook Lane. In front of these is a large cedar tree, one of a pair planted by Bunn in 1814, and just past the rear entrance of the Old Bath Arms on your right as you go up towards Christchurch Street. If still hungry for information about Bath Street and the numerous occupants since its construction, Derek Gill's book *Bath Street, Frome* should satisfy most appetites.

Bennett, Vicar

Around two centuries after **Joseph Glanvill** had been vicar of St John's Church, Revd William James Early Bennett (1804–86) came to Frome in a flurry of controversy. Bennett became vicar in 1852, having been driven out of his previous position at St Paul's in Knightsbridge due to his Anglo-Catholic views and membership of the 'Oxford Movement'. He outraged staunchly Anglican colleagues, as well as his congregation, by encouraging 'ritualistic practices' that went against the heart of their core teachings. Despite much protest – more than 600 people signed a petition against his appointment – he came to Frome, a town already well used to variety within its Christian worship. He found the church in great distress, physically and spiritually, and between 1860 and 1866 spent around £40,000, much of it his own money it has to be said, turning the building from a 'ruinous heap' into a fine Victorian church.

Sadly, Revd Bennett had no time for history in general or the church's specifically and says in his book *The Old Church of St John of Froome* that during building works he discovered the foundations of the Saxon church. He seemingly then made sure no one else ever would. It was also reported workmen came across indications of early Saxon internments but Bennett, 'fearing that some antiquarian would interfere had them quickly covered with quicklime'.

Despite continuing doctrinal disagreements locally, his immense hard work won respect and he remained there until his death in 1886. One of the most enduring aspects of his legacy is the *Via Crucis* alongside the steps on the north side of the church. There are several books about Bennett, both on his life in general and his

controversial time in Frome. These include Geoffrey T. Day's *William James Early Bennett 1804–1886: A Short Biography* and *The Story of W. J. E. Bennett Founder of S. Barnabas', Pimilico and Vicar of Froome-Selwood and of His Part in the Oxford Church Movement of the Nineteenth Century.* This somewhat snappy title of a book was written by Bennett's nephew, Frederick.

Blue House

Undoubtedly one of Frome's most distinguished buildings, and one of only two with Grade I listing, the present structure was completed in 1724, near the site of an earlier almshouse. It was paid for by public subscription, and was to be a school for twenty boys, as well as a home for twenty old ladies. The school was a charitable institution of a type known as a Bluecoat School, founded in the sixteenth century, which gives it its name. The boys occupied the central part and the old ladies lived in either wing. The building is now divided into sheltered retirement flats.

The two stone statues on the building's façade are known as Nancy Guy and Billy Ball: Nancy in her niche high up on the first floor and Billy on a plinth in the broken pediment above the door. Exactly who they were and what they are doing there is now lost in the mists of time. Two further statues, both serving maids, which now stand in the house's back garden, were rescued from Keyford Asylum, located unsurprisingly up at Keyford, when it was demolished in the 1950s. It is quite shocking to think, given

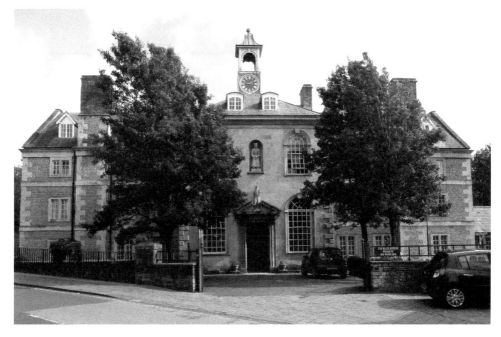

The Blue House of 1724.

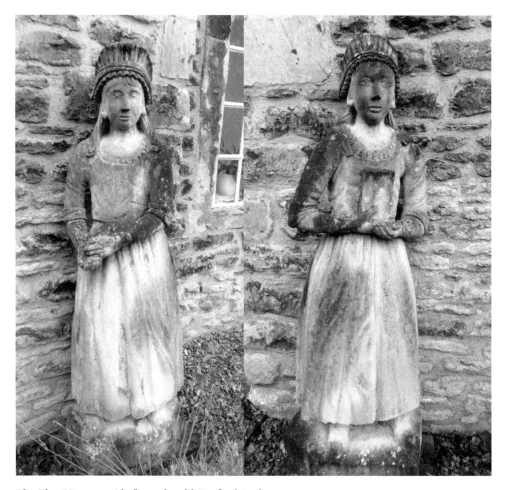

The Blue House maids from the old Keyford Asylum.

its current listed building status, that the Blue House nearly went the same way, but common sense prevailed, and its architectural beauty can still be enjoyed today.

The Blue House Restored, published in 1965, is well worth a read if you can find a copy, as is *The Blue House Past and Present*, which was revised by Hilary Daniel in 2010 and published by the Trustees of the Blue House. The original edition, from 1997, contained a text by renowned local historian Michael McGarvie.

Bookshops

Along with the plethora of charity shops in the town, which sell second-hand books, and the various markets and fairs that regularly cater for bibliophiles, Frome boasts two permanent bookshops, located a short distance from each other. The award-winning Hunting Raven (aka Winstones), residing at No. 10 Cheap Street, has a wide

Hunting Raven, Frome's premier bookshop.

and varied selection of new books, including a great children's section and another on local history. The other establishment – Frome Bookshop – is at No. 18 King Street, across the road at the top end of Cheap Street, and has a serious selection of antiquarian and other second-hand books.

Breweries

In centuries gone by Frome was always well supplied when it came to beer, as its relatively hard water was ideal for brewing certain types, especially bitter, and the results gained an enviable and far-reaching reputation. One notable London eighteenth-century publication said of Frome, 'This Town is noted for rare, fine, stale Beer, which they keep to a great Age, and is not only esteemed by the common People, but many of the Gentry prefer it to the best French or Port-Wines.'

During the eighteenth century and beyond, most public houses brewed their own beer and so the choice was wide and varied. On a 1774 map of Frome, there were no fewer than forty-three public houses – including such names as the Spread Eagle, King of Prussia, Crown & Thistle and Jolly Butcher. At the time beer was healthier for you then drinking water – some claim it still is – and the proliferation of beer-brewing establishments arose as a direct result of combating the more health-damaging gin houses. By the beginning of the twentieth century the big breweries began to dominate and in more recent times there has been a small fight back with micro-breweries gaining ground. The Griffin has gained numerous awards for its home-made brews.

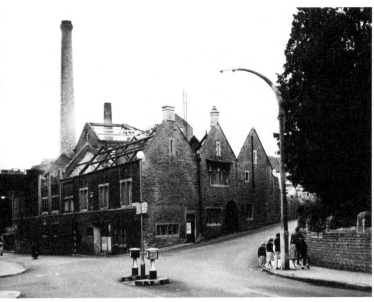
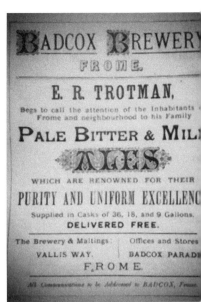

Above left: Lamb Brewery demolition, 1950s.

Above right: Wheeler's Almanac. Badcox brewery & Trotman Beers, 1882.

Of the old Frome breweries, the one most remembered today – even though production had ceased in the town by the beginning of the 1960s – is the Lamb brewery at Gorehedge. It was run by two members of the renowned Baily family, John and Thomas, whose extensive brewing interests existed throughout both East Somerset and West Wiltshire. Along with the brewery, they owned the Lamb public house on the same island site until 1887 when it moved to the corner of Bath street and is now The Cornerhouse. Ancillary buildings to the substantial brewery remain converted to residential dwellings.

Other concerns, such as the Swan brewery and another run by the Trotman family, were equally prestigious, and included smaller breweries at what is now The Old Bath Arms, and one at what was The Castle, off Catherine Hill, known as Knight & Gunning's Castle Brewery (another member of the Knight family had a brewery at Keyford). The later history of brewing in Frome is a story of consolidation, with mergers, partnerships and amalgamations. The majority of those mentioned above became the Frome United Breweries Company, based at Badcox. Mick Davis & Valerie Pitt's exhaustively researched *The Historic Inns of Frome* has more details of these breweries, alongside the pubs of the town.

Bridges

There are several bridges around Frome, but the most notable are the Town and Button ones. The Town Bridge, at the bottom of North Parade, near the centre, has

probably been a crossing point since Saxon times, and the bridge itself has had at least four re-buildings or realignments since 1540. What makes this bridge so special are the nine full-scale buildings on it, making it only one of three such structures in the whole country – the others being in Bath and Lincoln. The buildings on the bridge were constructed in 1821 and have served a variety of uses since then. Of possible interest is the book *Onto the Bridge*, a memoir by Geoff Swaine, whose family had two properties on the bridge and ran a tailoring business from there between 1840 and 1936.

The other significant bridge in town is Button Bridge, named for Formula One racing driver Jenson Button – one of Frome's famous sons – after he became World Champion back in 2009. From the Town Bridge you reach this other one by going along Bridge Street, turning left, and then across the car park in the direction of the Waterloo housing development. Visitors may be somewhat surprised to see this structure is, in fact, a pedestrian bridge. The truth of the matter is that it was already being planned to replace the old Baillie bridge before Jenson secured his sporting immortality and the town council at the time, it seems, decided to jump on the bandwagon. For those with an avid interest in all things Button, a similarly named street, located off Vallis Road, has absolutely nothing to do with Jenson's family.

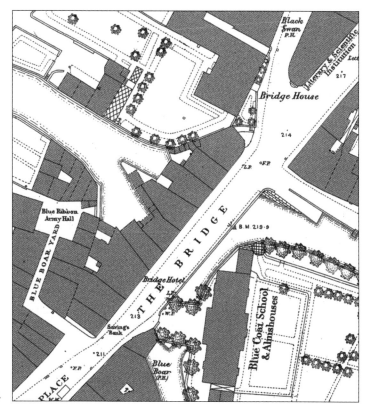

The Town Bridge in 1882. Ordnance survey.

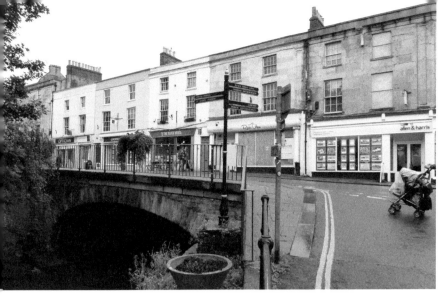

The Town Bridge Houses of 1821.

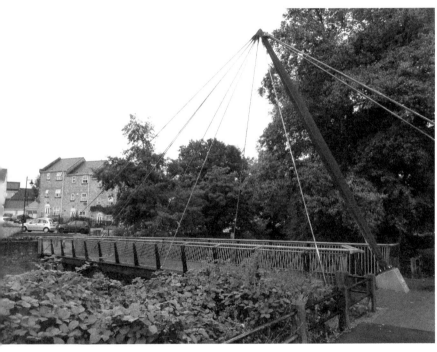

Jenson Button Bridge.

Bunn, Thomas

During his lifetime, Thomas Bunn (1767–1853) was one of the town's great benefactors, responsible for several of its most impressive classical buildings and charities. He trained as a solicitor but having become independently wealthy through the death of his father, seldom practised the law, preferring to spend his time in philanthropic pursuits and classical architecture. Unfortunately, although thankfully some might say, he never fulfilled his vision of making Frome into another Bath – with its

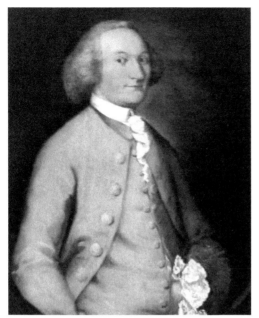

Above left: Thomas Bunn 1767–1853.

Above right: Bunn's grave, Christ Church.

sweeping crescents and exquisite squares – and when he died, his self-drafted will, in which he left much of his assets to the town, was so long-winded and undecipherable that the majority went to distant relatives. Nevertheless, his legacy can still be seen throughout the town and he is buried in Christ Church graveyard, where his grave is marked by a tree and rather utilitarian fence.

For further reading on one of modern Frome's founding fathers, see the book *Experiences of a 19th Century Gentleman*, published by the Frome Society for Local Studies and edited by Derek Gill, which contains Bunn's diary entries between 1836 and 1850.

Burne-Jones Windows

Edward Burne-Jones (1833–95) was the son of a Birmingham picture framer and became one of the leading designers and painters of the Victorian era. He met William Morris when a student at Oxford University and the pair went into business as William Morris & Co. creating a successful design and manufacturing company. His connection with Frome is through the several panels that reside in the town's Trinity Church, at the end of Trinity Street. These were commissioned at various times by local church members and date between 1866 and 1896. Very much worth a visit.

Butler & Tanner

As noted elsewhere in this book, chemists were one of the first to engage in printing in Frome, initially producing their own labels but then branching out into endeavours such as pamphlets, newspapers, books and various other printed materials. One such chemist was William Langford, who ran a pharmacy at No. 20 **Bath Street**, along with the selling of other divergent commodities. In 1844, Langford took on a partner, Mr William Thomas Butler, and the business became Langford & Butler. The following year a small printing press was installed in nearby premises. As well as printing labels, they produced the first issue of the *Frome Almanack* (a publication that continued until the Second World War). By the early 1850s, they had accumulated so much business that they had to move – or rather Butler did – to a site within the Trinity area. By now the partnership had been dissolved, although for a short while Langford still produced the *Frome Almanack*, while Butler printed it.

In 1857, or thereabouts, Butler went into partnership with Joseph Tanner and the firm that would eventually become the largest privately owned printing press in Europe came into existence. With the block expiry of leases and the depressed property market in Trinity, through the collapse of the town's cloth industry, the firm bought up houses adjacent to their press. In 1866, these made way for what became the company's Selwood Printing Works. Although Butler retired in 1867, the firm continued as Butler & Tanner and through the rest of the nineteenth century their growth seemed unstoppable. In the year the building of the Selwood Printing Works began, the firm employed around 150 people. Around twenty-five years later, this had increased to almost 500 and a relocation looked a necessity once more. By then, it was said the firm was producing 12 million books, magazines and pamphlets a year. Butler & Tanner moved to a site at Adderwell, across the far side of the town, and strategically nearer the railway station, just down the road as the crow flew.

As their business continued to expand, so did the machinery they used to produce their output. In 1911, for example, they installed a 'Dreadnaught' press – the first capable of printing 192 pages at once – while in 1935 they introduced the first automatic hard-back binding production line in Europe. Legend has it that in this year they were also responsible for printing the first of the famous Penguin paperbacks. It is perhaps no surprise then that they were, for a long time, the town's biggest employer.

The Second World War saw the company having to leave Adderwell and several elements of their prestigious output were lost due to this development, although the book printing side continued unabashed in the post-war period. Million-book runs were not unheard of and the firm undertook the printing for many major publishing houses, including the BBC.

In 2007, exactly a century and a half after it had begun, Butler & Tanner announced it was insolvent and despite a short-term rescue package, the following year it dismissed its greatly reduced workforce and started the process of auctioning off its assets. At the very last moment, however, millionaire publisher Felix Dennis – who back in

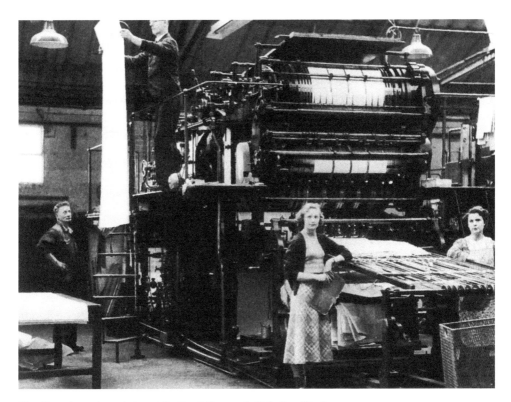

The Dreadnought printer at Butler & Tanner's Printing Works.

the 1970s had been one of the three defendants in the infamous Oz trial – stepped in and saved the company. Although it continued as a smaller concern, renamed Butler, Tanner & Dennis, its reputation remained intact and when in 2014 the axe finally came down on the firm, it was due to external forces rather than internal economics. For many people in the town it is still hard to believe the company has gone, for others it is absolutely scandalous that it was allowed to happen.

C

Cafés

Yes, there are lots of cafés in Frome, much to chagrin of some locals, but to the delight of visitors and newspaper editors who like to use this proliferation as a justification for the town topping several lists of best places to live. La Strada, top of Cheap Street,

Former Black Swan pub, now a café and arts centre.

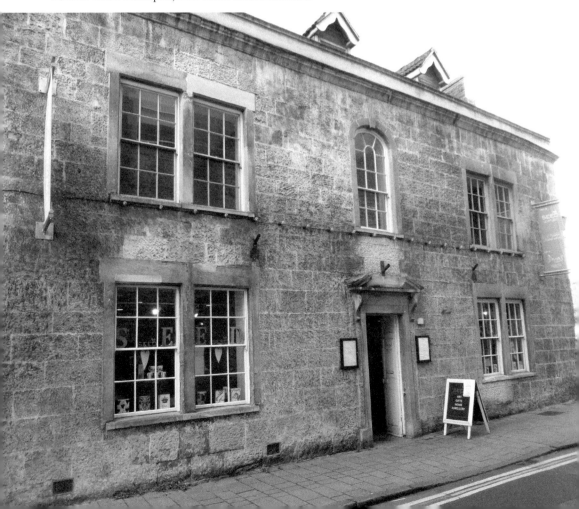

the Riverhouse on the Town Bridge, the Garden Café in Stony Street, Moo & Two on Catherine Hill, Black Swan Arts Café in Bridge Street and Coffee #1 in the Westway are just a few of the very many that exist, all of which have been favoured and frequented, at one time or another, by the authors.

Catherine Hill

One of Frome's most iconic streets with its steep slope and cobbled surface, it forms part of the town's original medieval street pattern in an area that also includes Catherine Street, Palmer Street, Paul Street and Stony Street. Although Catherine Hill has been a commercial part of the town for many centuries, by the mid-1990s it was in steep decline (pun intended) with many of its shops boarded up. Matters began to revive sometime after 1995, with a large government grant and cheap rents that encouraged several small traders to move into the old shops. These days, there is a relatively rapid turnover of businesses that keeps the area fresh, selling anything from classic gifts and vintage specialists to stylish clothes and ceramics, along with a plethora of art galleries, cafés and restaurants. It also provided a backdrop to the

Above: Catherine Street in 1990.

Right: Catherine Hill in 2020.

BBC's *Drover's Gold*, a television series transmitted in 1996 and that had Ruth Jones among its cast, later of *Gavin & Stacey* fame.

Cheap Street

One of the oldest and most pleasant streets in the town centre, it was first mentioned by name in 1500 and stands as the original business quarter of medieval Frome. The name 'Cheap', ubiquitously common in old towns, denotes a street of merchants, rather than alluding to the monetary value of the merchandise on sale within. Despite a devastating fire in the 1920s – known as **The Great Fire of Cheap Street** – much survives from the eighteenth century and before; of particular note is No. 11, the penultimate shop on the left heading up from the Market Place, which was built in around 1500 and still retains a carved Tudor rose on a beam inside. The leat, running down the middle of the entire length of the street, is fed from one of the area's many natural springs and eventually feeds into the river by the Town Bridge (see **Bridges**). In recent times, SATCO (Sunday Afternoon Theatre Company) has successfully ascended it, climbing up its length as if a rock face, and in the BBC series *The Fall and Rise of Reginald Perrin* its title character – played by Leonard Rossiter – descended it, while in the early years of the twentieth century a fishmonger, Mr Vincent, was known to clean his fish within it!

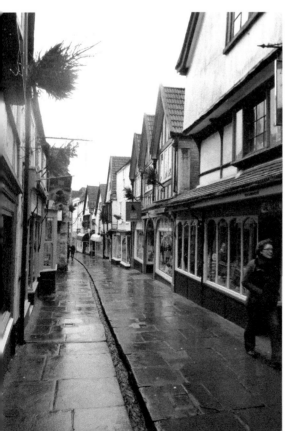

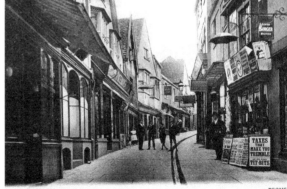

Above: Cheap Street in 1903.

Left: Cheap Street in 2020.

Cheese & Grain

Built in 1875, when all the various town markets were brought together in one place in an area that is now the main car park, the former Market Hall, as it was formerly (and perhaps more sensibly) known, was right next to the railway line with a special siding at the rear which allowed the town's produce to be speedily transported nationwide. With the decline of the livestock market and its move to Standerwick, the building went through numerous permutations, which included meetings, performances by Frome Operatic Society, a furniture warehouse and, of course, the centre for the annual Cheese Show until 1920. During the First World War it was requisitioned by the government and used for the manufacture of shell cases, which was undertaken by Frome's legendary firm of J. W. Singer & Sons, while subsequently, the place was used for storage by Benchairs and Channel Plastics.

Since 1998, the Cheese & Grain has become Frome's main venue of choice for live music and performance – disagree if you dare – attracting famous acts from the genres of rock, pop, blues and country, many of the top names in comedy, as well as playing host to an eclectic mix of activities, such as a beer festival and regular Bingo nights. A special mention though, must be given to the secret gig world-famous American rock band the Foo Fighters played there in February 2017. Doubling up as a low-key warm-up gig to thank long-time fans and a platform to announce their forthcoming headlining appearance at that year's Glastonbury Festival, it put the venue on the worldwide map to an unprecedented degree. It just needs to increase its capacity a little – a long-held dream of its management team – and it truly would be able to reflect through its musical offerings the world-class reputation it now holds. The venue is either tucked away or stands majestically – depending upon your viewpoint – at the back of the car park off Bridge Street and Justice Lane.

The Cheese & Grain music venue.

Cheese Show

Now known as 'Frome Agricultural & Cheese Show', and held at the West Woodlands Showground in Bunns Lane, near Frome, this event has been an annual occurrence since 1861, firstly, as part of its name suggests, as an exhibition of local cheeses and dairy products, but later diversified into livestock and poultry. All festivities ceased during the cataclysmic years of the First World War, before which it had been held in the **Cheese & Grain**. In 1920, due to the show's expansion, the organisers decided to purchase their own land between Frome and Clink, to the rear of the Vine Tree pub and Rodden Road.

When the Second World War broke out in 1939, the Cheese Show once again found itself cancelled for the entirety, reopening in 1946. Gradually the skills of hedging, thatching, ploughing and root growing, all of which had been so encouraged before the war, were phased out. The post-war years must have proved very popular and profitable, as debts were finally paid off and a reserve built up. In April 1999, 50 acres of land became available off Bunns Lane and so the present site was purchased.

The show date has become fixed as the second Saturday in September each year and the event is now very much a 'country meets town' extravaganza with an incredible diversity. This includes the gigantic cheese marquee, the Livestock Village, the largest one-day cattle show in the country, food halls, home & handicraft and horticulture marquees, and the Village Green, along with a programme of live entertainment, a rural pursuits area, the main ring with its day-long of mainly equestrian classes and a huge variety of trade stands. For further reading on the show's history, see the article in the Frome Society for Local Study (FSLS) Yearbook Vol.7 (pp. 24–30). Its author, Phil Cary, is a former chairman of the Cheese Show (2001–06) and member of a family closely associated with the show from its very beginnings.

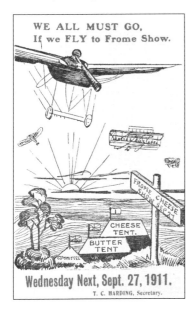

The Frome Cheese Show takes off, 1911.

Cinema

A Frome cinema seems to have been in existence almost from the birth of motion pictures itself. The first one seems to have been in Vicarage Street, in the building now run by Dores & Rees auctioneers. The building was requisitioned by the military during the First World War, but on the cessation of hostilities, the cinema moved to the bottom of the Church Steps, where it remained for several years as the 'Palace Theatre'. In 1922, it acquired a competitor in the 'Vaudeville Pavilion' – a cinema that opened along Christchurch Street East and lasted less than two months. It opened to packed houses in September 1922, but fell foul of the local magistrate, who closed it down for being a 'danger to the public'.

Perhaps no cinema is remembered more fondly than the Gaumont in Cork Street, just off the Market Place. This was an art deco Picture Palace, which really set it apart, as its style of architecture was almost unknown in the town. It opened in the mid-1930s, but was demolished in the 1970s, to be replaced by the present building – which has all the design flair of having been drawn by a trainee architect on a Friday afternoon following a heavy lunchtime session at the nearest hostelry. If one should never judge a book by its cover, then one should not judge a cinema by its exterior, because inside the Westway Cinema is a different matter. If a family-run venue with three screens, comfortable seats, and an enviable selection of the latest films is not enough to entice you, the absolute clincher is that all standard tickets are priced at a wallet-friendly £4!! Plus, you can get a drink, as well as the usual ice cream and popcorn to accompany your movie-going experience. It also seems the cinema has the ability to create its own history of a kind, with a recent example of the person who reportedly saw all nine instalments of the *Star Wars* saga at the time of their original releases – between 1977 and 2019 – at The Westway.

Below left: The Westway Cinema, Cork Street.

Below right: Dore & Rees auctioneers which housed Frome's first cinema for a time.

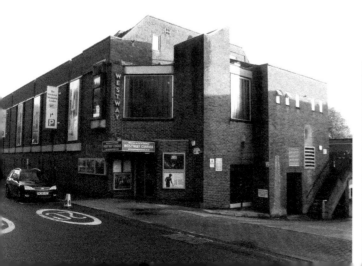

If there was a cinema to rival the Gaumont in its heyday, it was the Grand, located in the Memorial Hall, on Christchurch Street West. The Hall was built in 1925 as a memorial to those local men who had died during the First World War, but by 1931 it was leased as a 'talking picture theatre'. In the battle between the two, the Grand won a victory of sorts, having remained open after the demise of the Gaumont, but finally closed its doors in 1985.

Cockey's

The story of the family whose name has become so intricately linked with Frome began in nearby Warminster. It was here that Lewis Cockey (1626–1711) worked as a brazier (a person who works with brass), a bellfounder and a clock smith. It was his second son, Lewis Cockey Junior (1666–1703), who moved to the town in 1682 as a pewterer and bellfounder, beginning a business next to his home at No. 45 Milk Street, known as 'The Bell House'. Business was good and a foundry was soon established in the appropriately named Bell Lane, a short distance away. In the slum clearances of the 1960s this latter historic landmark was demolished and bulldozed away.

The family name of Cockey soon gained a reputation far and wide and at least twenty-three churches in Somerset – including St John's in Frome – and more than forty throughout the neighbouring counties of Wiltshire and Dorset bear inscriptions on their bells. After 1752 though, it seems the bells were cast elsewhere, while the headquarters remained in the town.

In 1816, Edward, a descendent of Lewis Cockey Junior, established his own firm. Initially a brazier and ironfounder in the Market Place, he moved the company to Bath Street in 1821 and diversified by becoming a successful ironfounder who began casting for the gas industry, building his own gasworks at Welshmill managed by his son, Henry. Through this endeavour Frome became, in 1831, one of the first towns to boast gas street lighting and Cockey became responsible for almost the entire trade of gas plant production in the West Country with many contracts abroad.

Gas pipe installation was not without its dangers. During the evening of 14 May 1871, a tremendous explosion rocked the area adjacent to the Ship Inn, on Christchurch Street West. Many people were either knocked to the ground or thrown in the air while at the same time, a water closet exploded, and a long stretch of paving stones were torn up, although thankfully there were no fatalities. The cause was traced to a recently installed gas pipe having leaked into drains.

The firm expanded its business throughout the remainder of the nineteenth century, to the point where, in 1893, they had outgrown their premises in Palmer Street (with its foundry behind Nos 10–15 Bath Street). By now Cockey was casting all manner of products, including fences, gates, stairs, balustrades, boilers, valves, steam engines, roofs and gasometers. This change saw them move to the Garston

area, east of the centre, onto an open site. Like their gasworks at Welshmill, a siding off the main railway line was constructed into the works, in order to help transport output. As well as the new buildings erected at this site, there was a large space for the pre-assembly of gasometers, before they were dismantled and taken off by rail for delivery.

Cockey's continued successfully through the early twentieth century, before being taken over by Bath Gas, Coke & Light Co. in 1934. Later still, the industry was nationalised and over the years all signs of Frome's gasworks were removed, and the firm was wound up voluntarily in April 1960. Despite Edward having sixteen children, it seems no members of this famous Frome family are left in the town, but firm's name lives on through the numerous bollards, gateposts and drain covers that are dotted throughout the town. Around 200 Cockey gas lamp standards were erected in Frome during the nineteenth century, all of which were converted to electricity at the beginning of the twentieth (and also fitted with a replacement art nouveau leaf pattern lamp-holder). Of these around sixty survive today and many have lost their leaves, have had obtrusive modern lights added, or require substantial repair prompting a project by Mendip District Council to bring the lamps back to their former glory, which is only right given the fact that at least twenty of them have been Grade II listed by Historic England. There is a twist in the tale, in that these protected lamps have also been attributed to the equally famous firm of J. W. Singer and according to the surviving records of Frome Urban District Council meetings, they were at least designed by Singer.

The head of one of Cockey's iconic lamps.

Dancing Bear

Not something that you would see every day – even in Frome. This photo, in Frome Museum, was taken in Christchurch Street East in 1898. The bears were made to perform in streets and outside pubs for money. It was a particularly cruel form of entertainment, with the bears bred in captivity and trained to perform from an early age by cruelty and violence.

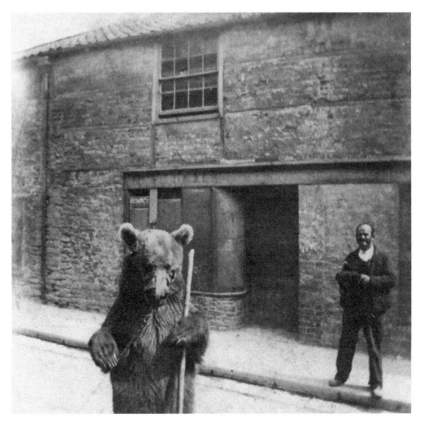

Dancing bear, Christchurch Street West, 1898.

Deadly Is the Female

Ordinarily, this popular vintage clothing shop, located in Catherine Street – a little further on from the top of Catherine Hill – would have resided firmly under S, in Shopping, with its fashionable array of clothing, footwear and accessories given a brief, but nonetheless appreciative and well-deserved mention. What entitles this noirish-named independent boutique to its own entry occurred in 2013, the year that Nigella Lawson – food writer, journalist, television broadcaster, daughter of former Chancellor of the Exchequer, Nigel, etc. – travelled to the United States to co-star alongside (the now late) celebrity chef Antony Bourdain in reality cooking show *The Taste*. Wanting to make an immediate impression on American audiences, she wore what became famously known as the 'wiggle' dress. It is fair to say that this figure-hugging red frock caused a media sensation and launched countless imitators, or at least it did once Nigella had tweeted her 300,000 followers the name of the place where she had bought it – Deadly Is the Female. The result was that founder Claudia Kapp was inundated with orders for what is officially known as the 'Billion Dollar Baby Dress' and is, ironically enough, made in California by Stop Staring! A headline in the *Daily Mail* summed it up: 'Nigella wows America with her £175 plunging "wiggle' dress" … and sparks sales frenzy at the tiny West Country store where she bought four.' Once again though, it was a case of the world catching up with Frome. As Crysse Morrison revealed in her 2018 book *Frome Unzipped* – along with the photographic evidence to prove it – local award-winning poet Rosie Jackson had been wearing *that* dress in 2011, a good two years earlier than Nigella.

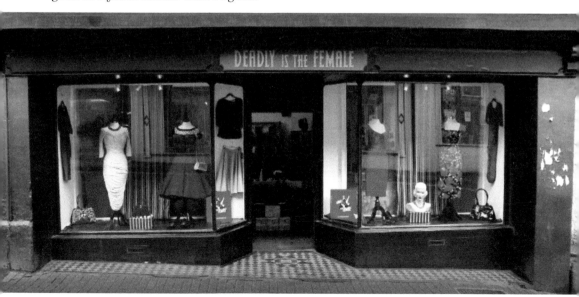

Deadly Is the Female.

Druid Stones

If you drive out of Frome on the A362, heading towards Radstock, you will soon pass the entrance to Orchardleigh, at one time the manorial home of the historic Champneys family but now a hotel, venue and golf course. Just off the road to the golf course, upon Murtry Hill, lie the remains of an earthwork and two standing stones. Excavations in 1920 found Roman coins and pottery there, while the barrow itself was described in the 1730s by John Strachey, the Somerset geologist and topographer as,

> Composed of small stones but turfed over. Some years ago viz about 1724 or 1725, taking away several loads to mend ye highway the workmen discovered the bones of a large man by several smaller skulls, lying in a sort of chest having two great rude stones at head and feet, two side stones and a coverer. Some say a great number of bones. The barrow is ovall, has a pit or hollow in ye top and at ye east end are now remaining two upright stones about 3ft high which if opened might probably discover such another chest of skeletons.

Local legends, recorded in the nineteenth century, reported that people disliked passing the monument after dark, and that a golden coffin was buried beneath it. A workman in 1872 is alleged to have dug down to find the stone's bottom and penetrated 10 feet

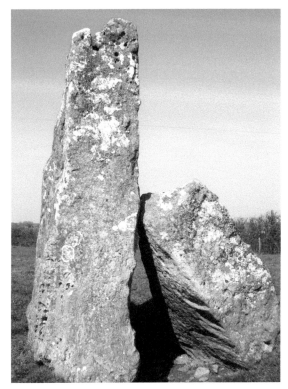

The 'Druid Stones', Orchardleigh. (Jennie O'Kane)

without reaching it. It must have been somewhat of an embarrassment if this workman was still alive forty-eight years later, when St George Gray's excavation showed the stone to be set into the ground a mere 18 inches! Alternatively, the workman may have died back in 1872, during his attempt, as another tale recounts the great stone to have fallen and crushed a workman and then returned to its position of immovability – could it be this same workman who dug down 10 feet without finding the base?

Like nearby Fromefield, little remains today of what was probably a Neolithic long barrow apart from the two stones and several bumps in the ground. The standing stones were in all probability arranged in their present position in the eighteenth century, so as to give them the sort of picturesque setting fashionable at the time.

The story of the barrow and others in the area are covered in detail in *Of Mounds & Men, Prehistoric Barrows of the Frome Area* by Mick Davis, published 2020 by FSLS.

Eadred (Edred)

When King **Athelstan** died in 939, his half-brother, Edmund I, succeeded him and ruled for the next seven years. His end came through a fatal stabbing in 946, and his place on the English throne was taken by his younger brother, Eadred, who was crowned in August 946. Despite health problems, this new king proved an effective war leader, defeating Eric the Blood Axe at York, and re-enforced royal authority in Northumbria. Towards the end of his life he suffered from a digestive malady which would prove fatal and it was on a visit to Frome in November 955 that he died, at the age of thirty-two, unmarried and childless. He was buried in Winchester Cathedral and was succeeded by his fifteen-year old nephew, Eadwig. Possibly not much of a connection, in retrospect, but how many towns can claim the death of an English king?

Ecos

The European Community of Stones (ECOS) Amphitheatre stands next door to the 240-seater Merlin Theatre, a registered charity run by a small team of professionals and an army of volunteers and located on the campus of Frome College, off Bath

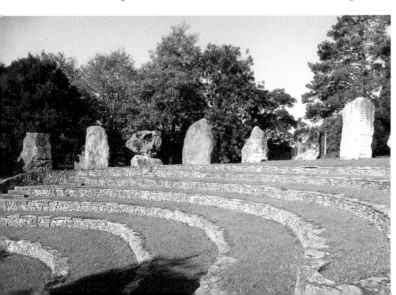

Merlin Theatre's Ecos stone amphitheatre.

Road. The amphitheatre is comprised of twelve huge megaliths – symbolising a common purpose and unity for the young people of Europe – which were donated by each of the dozen founding nations of the European Union back in 1992. Starting from left to right, with the car park as one's vantage point, they are Spain, Germany, Luxembourg, Italy, France, Ireland, Denmark, Netherlands, United Kingdom, Portugal, Belgium and Greece. Despite the United Kingdom's impending departure from this community, at least at the time of writing, this is an incredible and imposing structure, from an original artistic concept by Barry Cooper, which deserves to be better known.

Eels Feet (Pickled)

In March of 1859 John Provis was taken to court by Mary Applegate for assault. It appears that the complainant and defendant were both the servants of Mr Gough of Bath Street. Applegate had sent Provis, an old man not remarkable for brilliancy of intellect to Messers Lewis in Stoney Street for two pennies worth of 'pickled eels feet'. The unfortunate Provis returned to his employment with news to the effect that being pork butchers only, Messers Lewis did not deal in fish extremities. Realising what a cruel trick had been played upon him and not content with telling his master of the matter, he attempted to strike the complainant. She escaped initially but he later renewed the assault, striking her in the face several times and on the back with a brush. The case excited much laughter in court and on the conclusion the defendant was fined one shilling and costs of 6 shillings and ten pence. Ms Applegate was advised not to let off her practical jokes on her seniors in future.

Election of 1832

In December 1832, as a result of the Great Reform Act of that year, an election for a Member of Parliament to represent Frome was held at The George Inn, in the Market Place. Many small landowners, tenant farmers and shopkeepers were now able to vote, which meant that the electorate was increased to slightly more than 300 out of a population of 13,000. Thomas Sheppard, a retired London banker, was the first to put himself forward as a candidate and local worthy **Thomas Bunn** described his arrival in the Market Place with Sheppard: 'I was to nominate one of the candidates. I entered the town with him in a barouche and four with a long procession of well-dressed men, flags and a band of musicians. I was surprised at the Market Place to see a rank of Horsemen in hostile array. The drivers hesitated. I ordered them to force their way through. The flag was torn in pieces and the bearer knocked down. The candidate and his friends ascended the hustings, and except myself had literally their coats torn to atoms. All this was instigated by the opposing candidate, a well-known character with

whom no gentleman would associate. Our excellent magistrates were at last obliged to shoot some of the mob.'

This 'opposing candidate' to whom, at least in Bunn's opinion, it seemed no gentleman would associate, was Sir Thomas Champneys, the flamboyant baronet of

Tom Sheppard's version of the 1832 Election riots.

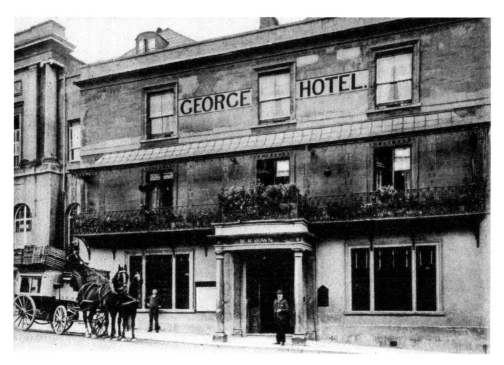

The George Hotel, scene of the 1832 riot, in 1905.

Orchardleigh. On paper, Champneys was the Tory, Sheppard for the Whigs. Both men were of great power and influence locally, in their mid-sixties and each had a long-standing hatred for the other. Despite all outward rhetoric, the election was mainly fought on who could cajole, bribe or otherwise influence the tiny number of electors in their favour.

The electoral process itself was scheduled to take place between 10 and 12 December 1832, and so did three days of rioting. Banners were torn down, opposing supporters attacked and special constables sworn in before Sheppard, perhaps fearing for his life, beat a hasty retreat back up North Parade to his home at Fromefield, where he barricaded himself inside, along with many of his supporters, until a detachment of dragoons could be summoned from nearby Trowbridge.

When everything calmed down and order restored in the town, the votes were counted and, to his apparent astonishment, it was announced Champneys had lost the election by 100 votes to 163 – a majority of 63 for Sheppard. The victor would go on to represent Frome for the next fifteen years, costing him a fortune in bribes, while Champneys never stood again.

Frome Festival

The annual Frome Festival was first held in 2001 and has become one of the highlights in the town's social calendar. It was conceived by Martin Bax, who became its director, to regenerate Frome and its community by giving it a focal point. Household names from Bax's address book – including Charles Dance and Frances de la Tour et al – peppered the inaugural festival, which took place (and still does) in July.

Martin Bax stepped down in 2007, and was subsequently awarded an MBE for his services, while his namesake, Martin Dimery, took over as director – a position he still holds, as of 2020. Frome Festival has gone from strength to strength, year on year, attracting 'big names' and was voted by *The Times* as being one of the country's top five festivals.

More than all the pundits' praise, however important these may be, is that it shows yet again Frome's ability to combine one person's vision with the populace's collective determination to realise that vision, and this maybe is the true key to its success, rather than the famous names it continues to attract. As Martin Dimery said in 2011, 'I think the big names aren't the real story. It's all the other events that help to make the festival such a success. Frome is packed full of the most talented people – writers, artists, musicians, organisers – and the festival is a true celebration of those

The festival that never was. Design for the 2020 programme.

talents.' At the same time, support behind the scenes, which was there from the very beginning, is just as important and forthcoming. This is best summed up by Martin Bax, when he reflected back in 2010 that 'every business that was approached for sponsorship was supportive in some way because they could see what the festival committee was trying to achieve for the town'.

The festival – which is run as a charitable trust – has also suffered its share of setbacks, including lack of funding and occasionally losing money on major events. The 2020 event – celebrating its twentieth anniversary – has been delayed until 2021 due to the coronavirus outbreak. But it has always proved resilient and long may it continue to do so.

Fromefield Barrow

Nothing to see here, but at one time the grounds of Fromefield House, to the north of the town centre, were home to a Neolithic long barrow to rival the one at Stoney Littleton and perhaps even West Kennett. Around 1820, the Sheppard family – wealthy clothiers who had been in the Frome area since the sixteenth century and who by now were the town's largest employers – decided to landscape the grounds near the house. Towards the northern edge of the gardens, near an old field boundary and footpath, there lay an inconvenient mound that they decided to have removed. As this was done, it was found to be an ancient burial chamber containing 'skeletons' and pottery. The story goes that they found a series of five chambers, all containing human remains, but which they covered over and left intact. The site was disturbed once more 145 years later when the current landowner decided to build houses on the

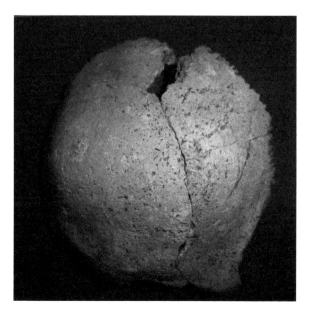

The 6,000-year-old cranium from the Fromefield long barrow.

The mysterious standing stones at Fromefield.

site. The Ministry of Works sent over their crack emergency rescue team, in the form of Faith and Lance Vatcher, who had previously excavated at Avebury and Stonehenge. Their investigations were cut short when the owner threw them off the site and it was levelled with a bulldozer, but not before they were able to extract what was later identified as the remains from at least sixteen separate individuals. Leystone Close now stands on the former barrow site. The remains are now in Taunton Museum and the story is told in full in *Of Mounds & Men* by Mick Davis.

Frome Hoard

In April 2010, metal detectorist Dave Crisp was prospecting on a farm near Frome when he discovered a pot which looked as if it held a large amount of Roman coins. Realising immediately that the find could be of great importance he called the local finds officer, who arranged a professional excavation. When the pot's contents were examined, it became the largest Roman hoard to have been found in a single container – 52,503 coins weighing 160 kg, and dating between 305 and 353 – and the second largest such hoard ever found.

When examined at the British Museum most of the coins were found to be base-silver or bronze radiate, but there were 760 coins – including five rare silver denarii – from the reign of Carausius, a Roman general who rebelled against the Central Empire and declared himself emperor in northern Gaul and Britain. The pot was so heavy when filled that it seems likely that it was buried in the ground before the coins were put into it, as it would have collapsed under its own weight if transported when full.

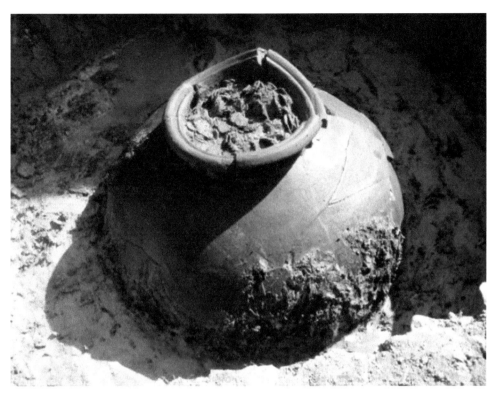

The Frome Hoard in situ.

Frome Society for Local Study

The Frome Society for Local Study was founded in 1958 with the main purpose of studying the archaeological, geological and natural history of Frome and its immediate surroundings. The meeting was addressed by celebrated archaeologist Sir Leonard Woolley. In the sixty or so years since its inception, Frome Society for Local Study has saved and restored historic buildings, instigated a plaque scheme, sponsored local history projects, created a museum, produced an annual yearbook, and published a vast array of books, booklets and pamphlets by local authors and historians, as well as having organised everything from archaeological excavations, lecture programmes, town walks, social outings and historical visits. With a current membership of more than 450 people, it is a testament to both the interest that remains in Frome's past and to its original aims. The FSLS is closely linked to the Frome and District Civic Society, whose role is to stimulate people's interest in the town, raise awareness of its special character and identity, promote civic pride, provide a forum for discussion about the town's future, and safeguarding of buildings and areas of historic interest, as well as campaigning for high-quality design and materials in new developments and fighting for better traffic and parking policies, along with, of course, safer roads. For further details see fromesociety.wordpress.com

Garston Lodge

Garston Lodge is a rare example, at least in Frome, of an architectural style known as 'Strawberry Hill Gothic', named after Walpole's innovative home in Twickenham. It dates from the early nineteenth century and its origins are obscure, but it was once home to the Toop family, who ran an agricultural merchants' business, and was the first house in town to be connected to a mains water supply. Since then it has suffered several indignities, which include having two shops tunnelled into its Vicarage Street elevation. In the early 1990s, the building was close to collapse, and was 'rescued' by a Londoner with the ambition to restore it as a family home. Sadly, this was not to be and at the start of the twenty-first century it was converted into low-rent flats. Its sad tale did not end there though, as in October 2018 a chip pan caused a disastrous fire that almost destroyed it. At the time of writing it is undergoing complete renovation.

Garston Lodge in 1992, before conversion.

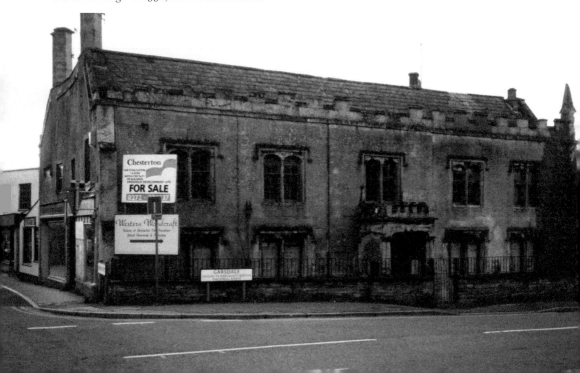

Gentle Street

Always one of Frome's most famous and recognisable thoroughfares, Gentle Street has become even more so since its appearance in the recent television adaptation of *Poldark*, based on Winston Graham's novels. Doubling as the Cornish town of Truro, the exterior of the former Waggon and Horses pub was transformed into the Red Lion, while a house further down the cobbled street became the site of Pascoe's bank. Gentle Street itself was mentioned as far back as 1300 and originally Hunger Lane, a name apparently derived from an Old English word meaning steep slope. By the late 1690s though, it had become known as Gentell Street, after the family that lived there.

As well as being picturesque, Gentle Street contains several of the oldest buildings in Frome, including Oriel Lodge, built in 1800, and Argyle House, built between 1766 and 1767. The latter, also known as No. 12, was built for Mary Jesser, a member of a family who were dyers and had premises across town at Welshmill. The Waggon and Horses (which closed as a pub in 1960) is even older, being mentioned on the site in 1703. During the heyday of the town's cloth industry, the Frome Flying Wagon, belonging to Joseph Clavey, set out from the pub by one o'clock in the afternoon every Monday and would reach the King's Arms, in Holborn, by noon on the Wednesday. Perhaps by far the oldest property, however, is No. 2 Gentle Street, which is possibly pre-1600 (though much altered since then). Originally the town house of the Thynne family, who normally lived at Longleat but owned substantial land within the town, the building is today divided into two and known as The Chantry and The Hermitage.

Gentle Street, one of Frome's most picturesque.

Gimblett, Harold

In May 1935, twenty-year-old Harold Gimblett, from Bicknoller, in West Somerset, had a two-week trial with the county's cricket club but was unsuccessful. Luckily Somerset Cricket Club found itself short of a player for a forthcoming game against Essex, at the old Showfield, Rodden Road, in Frome.

Somerset won the toss and chose to bat, but a disastrous start saw them lose their first three batsmen for just 35 runs, and by the time Gimblett stood at the crease, the score was 107 for 6. But then, as cricket bible *Wisden* would record, 'The start of [Gimblett's] career was so sensational that any novelist attributing it to his hero would have discredited the book.'

With a borrowed bat and an audacious stroke play, Gimblett's first run came off his third ball; his half-century with the thirty-third; and in just over an hour, he had reached his century. This landmark – which included 3 sixes and 17 fours – would become the fastest century scored that season and by the time Gimblett was caught 23 runs later, this Bicknoller native had become an instant celebrity. Somerset won the match with an innings to spare – thanks largely to Gimblett's contribution – and it is perhaps no surprise that his future county career flourished. Although his international career faltered – with a mere three Test appearances – his biographer would call him 'the greatest batsman Somerset has ever produced'. And there are probably very few people – especially those who watched his sensational debut at Frome on 18 May 1935 – who would have disagreed.

Glanvill, Joseph

Almost a millennia after Aldhelm built the original St John's, a vicar took over its living who would be responsible not only for the most influential book on witchcraft, but also be indirectly responsible for the infamous Salem Witch Trials in America.

Joseph Glanvill was born in 1636 in Plymouth and was raised within a strict Puritan household, a group of English Reformed Protestants who sought to 'purify' the Church of England from its 'Catholic' practices. He was educated at Exeter and Lincoln colleges, Oxford, where he gained his BA and MA, respectively. During these university years, he was already achieving somewhat of a reputation as a forward thinker and the philosophy he developed was one of religious toleration, along with upholding the scientific method and freedom of thought. Glanvill, by all accounts, was an intelligent man, whose zeal for science was matched only by his need to prove the paranormal and warn of its evils.

When the monarchy was restored in 1660, and Charles II on the throne, a reversion to the Anglican Book of Common Prayer was demanded. Those who did not adhere lost their living. In Frome, such a man was the vicar of St John's Baptist Church, John Humpfry, and when he vacated St John's in 1662 (and moved up the road to Rook Lane House to continue his preferred method of worship) Joseph Glanvill stepped

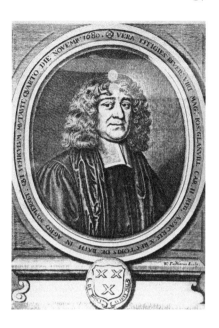

Joseph Glanvill 1636–80.

into his shoes. It was while in Frome that he researched and developed his ideas and chronicled episodes and incidents that would inform the contents of his greatest work – *Saducismus Triumphatus*. The book is essentially a compendium of case studies, which Glanvill compiled with his friend Robert Hunt of Compton Pauncefoot. Hunt was Member of Parliament for Ilchester and a Justice of the Peace, and he was tireless in hunting down witches. In many ways Glanvill and Hunt can be considered the first paranormal investigators. The 'cases' included an alleged witch who had supposedly put a spell on a twelve-year-old boy and was tried at Shepton Mallet, a wise woman from Wincanton accused of 'making charms and herbal potions', as well as the murder by witchcraft of a neighbour, and the spooky tale of two men who agreed that whoever should die first, would visit the other.

Saducismus Triumphatus went through several editions during Glanvill's lifetime, but only appeared in its final form in 1681, the year after he died. His legacy lived on and in February 1692, in Salem, Massachusetts, there began the infamous and notorious series of witch trials. The result of these 'trials' was that twenty people were executed, fourteen of which were woman and all but one by hanging. Five others (including two infant children) died in prison. One of the books that laid the groundwork for these trials and another subsequently written to justify them was by American Cotton Mather, who stated openly that he was heavily influenced by Joseph Glanvill's famous treatise.

Gorehedge

Now reduced to a patch of mud and a few trees, this small plot of land, situated at the top of Bath Street, once contained a group of Elizabethan cottages which, before they

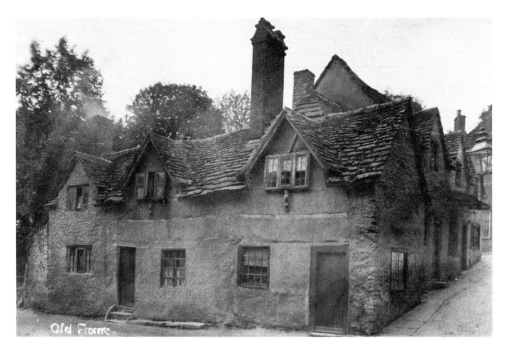

The ancient Gorehedge cottages.

were torn down in 1913, were probably Frome's most ancient buildings. Its name has led to the theory that it derives from the remains of Monmouth Rebels who were hung there, but the name is far older and means a triangular piece of ground.

Great Fire of Cheap Street

At around 10.45 in the evening, on Saturday 4 August 1923, a fire broke out in the premises of Bailey's, a draper's shop at Nos 9 and 10 Cheap Street. The shop was completely gutted, with flames reaching 30 feet in the air. At the time, it was described as 'probably the most disastrous fire in the history of the town'. The fire occurred in what was Frome's oldest commercial street and the ancient wooden-framed buildings burned with an intense heat. The blazing timbers collapsed across the narrow street and fell into No. 17, the premises of Jack Dance's outfitter's shop, where Mr and Mrs Dance were asleep upstairs. Fortunately, they woke up and, as the fire raged around them, narrowly escaped into a small yard at the back. From here they were rescued by means of a lowered rope.

The fire hooter could be heard as far away as Beckington and raised the whole town, with huge swathes of people arriving to witness the event. Soon, there were so many onlookers – in their thousands it has been said – the narrow streets were clogged to such a degree the police had to push the crowd back in order to allow the Frome Fire Brigade through. So rapidly did the fire take hold that it was feared the whole street

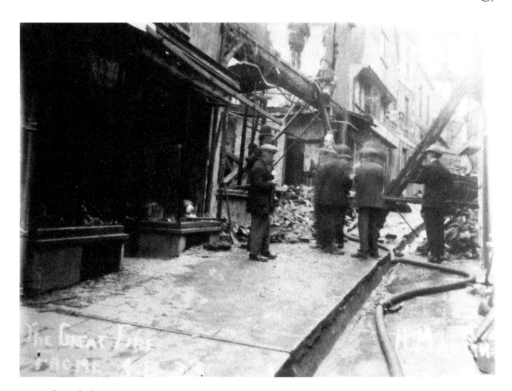

Great fire of Cheap Street, 1923.

might be consumed and perhaps even spread to King Street, but gradually the fire brigade gained control and by the early hours of Sunday the threat was contained. The fire brigade were not the only heroes of the hour. On hearing that a small child was asleep in an affected building, a member of the public, Mr Benger, dashed into the flame-threatened, smoke-filled room and rescued the child, sustaining severe burns to his face and arms in the process.

As to the buildings themselves, Bailey's was rebuilt and is now Hunting Raven bookshop, while next door, the badly damaged No. 8 is Frome Wholefoods. Across the street, No.17 is now Coiffure the hairdressers and the old Flora tearooms, once the Albion pub, continues as The Settle bakery and restaurant. The cause of the fire was never discovered but is thought to have been an electrical fault.

Heritage Trail

Frome Heritage Trail is a journey into the town's illustrious past and is based around sixteen plaques erected in 1985 for the Frome 1300 celebrations of its founding. The trail takes participants through the numbered plaques in numerical sequence, from the lowlands of the Market Place, Willow Vale and North Parade, to the giddy heights of Gentle Street, Vallis and Trinity area, with sights such as Catherine Hill, Whittox Lane and Cheap Street between.

An accompanying booklet published by the Frome Society for Local Study is available for purchase at various places around the town including Frome Museum. As well as further information for each plaque, it also contains an introduction to the town and its early days, a map, numerous images and a list of other FSLS publications.

Above: Willow Vale, part of the Frome Heritage Trail.

Left: The Frome Heritage Trail cover of booklet.

I

Independent Market

The Frome Independent is an award-winning street market, organised and managed by a trio of Frome residents, ably supported by a dedicated team on market days. It was established in 2009 and began life as St Catherine's Artisan Market. Founded by a Frome-based entrepreneur, its aim was to bring footfall to the independent shops of the town's picturesque cobbled streets within the St Catherine's area, including **Catherine Hill**. The market grew in popularity and expanded to include a flea and vintage market section. This grew once more in 2012, when a series of pilot events called 'Frome Super Market' expanded the enterprise across the entire town centre. Following the success of these pilots, and grant funding from Mendip District and Frome Town councils, the market was rebranded in 2014 as The Frome Independent. The market takes place on the first Sunday of each month, from March to December, and attracts several thousand visitors.

Setting up for the Frome Independent on a bright October morning.

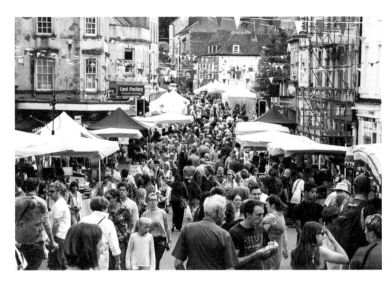

The Frome
Independent in full
swing.

Iron Gates

Iron Gates is the name of a house in King Street with seventeenth-century origins. It was remodelled in around 1740 and was for a long time one of several homes in the town belonging to the Sheppard family of wealthy clothiers. It has a fine-looking extension emerging from the rear, with a Queen Ann shell hood over the door. Although a listed building, it is sadly marooned within an awful 1970s shopping arcade, as well as having lost its curtilage. Although currently used as a pet shop, it is still worth a look around inside and one notable visitor in recent times was Hollywood actor Nicholas Cage.

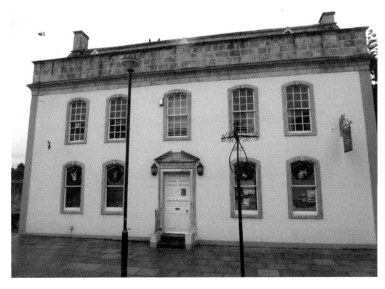

Iron Gates *c.* 1700.

J

Justice Lane

Justice Lane, off Bridge Street, near the centre of town, was once known as Edgell's Lane – after a prominent local family – and contained part of the dye works run by the Olive family; a permanent reminder today is in the shape of the **Round Tower**. It was also, before the police station in Christchurch Street West was built, the location of the Magistrates' Court – hence the street name. Those having to stand before the local magistrates to face charges would be escorted down the lane from the direction of Bridge Street, having been held in the conveniently located Guardhouse (see **Lock-ups**), which at the time stood adjacent to the Blue Boar in Market Place, or, if the charge was more serious, from Shepton Mallet prison, some 12 miles away. More often than not, and dependent of the severity of the accusation or notoriety of the accused, the prisoner would have to run the gauntlet of the local populace, who were lined up either side of the lane.

Edgell's Lane, now Justice Lane. Plot 1687 was the courthouse.

Ken, Bishop

There is little to connect Bishop Ken with Frome other than his grave at St John's Church. At one time the Bishop of Bath and Wells, Thomas Ken was deprived of his see after he refused to pledge his allegiance to William of Orange following the Glorious Revolution. He came to Longleat at the invitation of Thomas Thynne, the 1st Viscount Weymouth and an old friend from his university days. He spent the remainder of his life in quiet contemplation, writing hymns and exerting an influence on his congenial host, which resulted in the latter's regular undertaking of 'good deeds'. When he died in March 1711, his final wish was to be buried in the nearest parish to Longleat, which is how he ended up at St John's. His crypt was tacked onto the back of St John's Church in around 1847 and inside through the grill can be seen an iron grating which covered the original grave from 1711 along with an iron crosier and mitre which lay across the top of it. It is paved with some beautiful Minton tiles and displays an epitaph which he wrote himself: 'May the here interred Thomas Bishop of Bath and Wells and uncanonically deprived for not transferring his allegiance, have a perfect consummation of bliss both of body and soul – of which God keep me always mindful.'

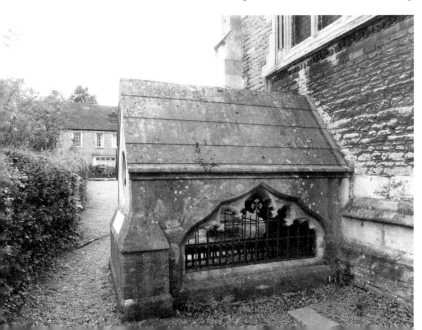

Bishop Ken's impressive tomb in St John's churchyard.

Keyford

This southern part of the town is mentioned in the Domesday Book, when it was a separate parish, and retains much of interest. Once it had a busy high street full of shops and tradesmen – a quick flick through the 1851 census for Keyford Street, the main thoroughfare, reveals a carpenter, dressmaker, currier, shoemaker, cabinetmaker, master mason, straw bonnet maker, innkeeper, baker, and blacksmith. Enough, no doubt, to supply most needs.

Of significance today is No. 25 Keyford Street, which dates from around 1750 and is probably the only surviving eighteenth-century shopfront in town. In 1851, the shop was a grocer's owned by Richard Grist, who at the time was also one of the town's constables. It was to this building that distraught father John Watts came after finding the murdered body of his daughter at their farmhouse – one of the town's most intriguing mysteries, still unsolved but examined in full detail in our book *The Awful Killing of Sarah Watts*. By 1900 it had become Walwin the grocers and in later years a video shop. It is now a private house.

Next door is the Crown pub – also mentioned in the Sarah Watts book – an ancient two-roomed inn and listed building dating back to at least the late 1600s and owned by the Pobjoy family for generations in its early years.

Despite its ancient feel, the area did not escape the attentions of the Grim Reaper – known also as the demolition man – and High Place, a fine Regency building located on the opposite corner from what was the Beehive pub, was destroyed to make the road wider in the 1960s. Nearby Keyford Asylum, at the top of what is now Stevens Lane, also went the same way a few years earlier. It was built at the start of the nineteenth century and was somewhat of a counterpart to the Blue House, situated in the centre, as its residents were old men no longer fit for work (as opposed to thc Blue IIouse's elderly spinsters) and young girls undergoing training for service (as opposed to boys being educated). It was also a military hospital during the First World War.

High Place, Keyford, being demolished in the 1960s.

At Lower Keyford stands what is possibly Frome's oldest building, known as the Nunnery House. Although much altered, it is thought to date from the early fifteenth century; the stone trefoil window is an exact copy of the original, which was beyond repair. The interior contained several wall paintings possibly dating from its earliest phase. During the 1820s the property was home to the Howarth brothers, whose history is recounted in our book *Foul Deeds & Suspicious Deaths in and Around Frome.*

High Place today – a wider road.

25 Keyford *c.*1750 and the Crown pub

Above: Keyford Street in 2019.

Below: The Nunnery House, Keyford.

Lamb & Fountain

The Lamb & Fountain at the north end of Castle Street (once known as Fountain Lane) is surely one of the oldest and least spoilt of Frome's pubs, and at the time of writing (April 2020) not only can it boast the longest-serving landlady in the country, but also the oldest.

Originally recorded in the 1753 church rates as 'The Fountain', its origins are thought to be much older and in 2005 a stone-built chamber – possibly an ice-house – was found beneath the building that pre-dates the existing structure by several years. The lower parts of the pub – though no longer in use – are built into the hillside and are a warren of ancient passageways, blocked-up doorways and sealed-off cellars, with a large former malthouse adjoining it.

From 1781 until 1799 it was referred to as the 'Old Fountain' and the Frome census of 1785 shows John Moon as proprietor and publican. By 1800, the pub is being referred to in the church rates as the 'The Lamb & Fountain', with a brewhouse and cellar attached.

Like most pubs that have any longevity, landlords and landladies came and went at the Lamb & Fountain over the subsequent centuries, many for short periods of time, others longer, until September 1969 when Harry and Freda Searle arrived. Things did not get off to a flying start, as 'Mother', as Freda would soon become known, said in a 2008 interview, 'The first Sunday we had one customer, and I cried and said we have lost our money. But then it got so busy I could not cope.'

Of course, Mother learnt to cope, as she did when husband Harry died in 1975, at the age of fifty-six. Determined to carry on, she retained its popularity and along the way acquired perhaps more than a fair share of legendary stories. 'We nearly had a birth in the passage once,' she recalled in the same 2008 interview, 'and another time we a had funeral party in [one] bar, all crying, and then a wedding party arrived without warning in the other bar and all started singing.'

A visit to the pub today will find it full of devoted regulars, practically untouched since the day Mother (and Harry) took over. There is a shove ha'penny slate (with heat lamp), darts, a piano, table skittles and, if you really must, a fruit machine in the front bar, along with a refreshingly small telly. It retains many rare features, like the

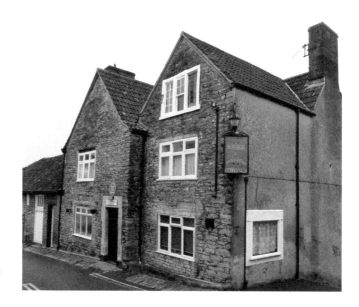

The Lamb & Fountain, one of Frome's iconic pubs.

sliding-off sales hatch in the entrance corridor, and the back bar, which is supported many feet into the air by a set of rusty iron poles. Meanwhile, the journey to the gents is a genuine test of skill, as it is down a flight of steep and treacherous steps – although in these gender-fluid times, some have been known to forego that adventure and nip into the ladies, just off the pool room.

Now retired from active involvement in the running of 'Mothers' – this is undertaken by 'Daughter' Sue – it is still Freda's name which appears above the door and at the time of writing, is in her 99th year – not bad for someone who started out washing glasses at the age of fourteen at the Red Lion in Somerton. 'Mothers' recipe for this longevity though, is simple: 'You have to be a psychiatrist, a doctor and a bouncer, listen to other people's woes and always have a smile on your face.'

Literary Frome

It has been said there are more writers per square metre in Frome than anywhere else in the world, but this is wishful thinking, though the reality is almost as good. Frome has an enviable and thriving literary scene which includes several award-winning and successful authors and poets. A great number of these belong to Frome Writers' Collective, an initiative launched in 2014 which now boasts more than 100 members.

The idea behind the group was to support and encourage writers in the locale, through providing a network in which to socialise, form a writers' group and become involved in a host of literary activities, including those for the **Frome Festival**. And it didn't stop there, as FWC now has its own imprint – Silver Crow – which has seen several members have books published, many for the first time. To prove how serious this idea was taken in the town, its patron is Barry Cunningham OBE,

the man who 'discovered' J. K. Rowling. After leaving Bloomsbury – the publisher who brought Rowling's Harry Potter to bookshelves everywhere – he co-founded The Chicken House, a publisher of children's and YA fiction. Although seemingly a small concern – a solitary plaque in Palmer Street marks its existence – it is part of Scholastic Corporation, which is one of the largest publishers of children's books in the world, yet, like most things in Frome, retains its independence.

In terms of historical literary connections, Frome cannot compete with certain other places in Somerset, who can boast the likes of Coleridge, Wordsworth and Southey as past residents, but the town has no reason to feel overawed. The sun shone bright on the 'careers' of Samuel Daniel and Elizabeth Singer Rowe in their day – the late sixteenth and early seventeenth for Daniel, late seventeenth and early eighteenth for Rowe – and even though it has long since dimmed and they are much neglected these days, they are not entirely forgotten. There is a plaque for Rowe on an outside wall of Rook Lane House, in Christchurch Street West, where she lived while in Frome and a monument for Daniel is to be found at St Gregory's Church, in Beckington, where he spent the last period of his life.

Other famous writers connected to the Frome area include Daniel Defoe (Frome), Christina Rossetti (Frome), Henry Newbolt (Orchardleigh), Siegfried Sassoon (Mells – where he is buried), Leonard Woolf (Mells), Anthony Powell (Whatley), Evelyn Waugh (Nunney) and just down the road in Bruton, Nobel Prize recipient John Steinbeck lived in 1959 while he pursued his study of King Arthur.

Of more modern-day writers, Frome can boast as residents Whitbread prize-winning author Lindsay Clarke, acclaimed award-winning novelist, poet and short story writer Gerard Woodward, Costa Book of the Year winner Andrew Miller (currently in Witham Friary), as well as *Guardian* journalists-cum-authors John Harris and Keith Stuart. Other notable names include Julian Hight, Dave Hamilton, John Payne, Peter Clark, Frances Liardet, Alison Clink and Crysse Morrison.

Local Historians

If Frome has a reputation for the prowess of its literary authors, this is surely equalled by the town's historians. There is a long tradition of inquisitive minds delving deep into Frome's illustrious and, at times, dark past and publishing the results to an insatiable readership.

The first name that should be mentioned is J. O. Lewis, who did not publish his extensive research in book form, but wrote copiously for local newspapers. His influence resonates today and much of his exhaustive notes were the acknowledged foundation of Peter Belham's *The Making of Frome*, published in 1973.

Before he died in June 1995, Belham was recognised as Frome's 'most prominent townsman and elder statesman'. He was the final chairman of the Frome Urban District Council (FUDC), before it ceased to exist in 1974, and later became mayor,

but his book will be justly remembered as the 'first serious historical work on the town', which traced its past from **Aldhelm**'s founding towards the end of the seventh century, up to the twentieth. His other works include *Saint Aldhelm and the Founding of Frome* and *Villages of the Frome Area: A History*.

Another well-respected local historian was Derek Gill. Born in Taunton, he trained as a teacher and moved to Frome, where he taught first at Milk Street School and then later Selwood Middle School. He researched the town's history and helped preserve many of its buildings and artefacts. He was closely involved with Roger Leech in recording the **Trinity** area and was a founder member of the Frome and District Civic Society. Elected a town councillor in 1976, as an independent, he also instigated the town walks. He was committed to **Frome Museum**, which he helped to move from Wine Street to its current location. He wrote several books, including: *Frome School Days*; *Bath Street, Frome*; *Willow Vale*; and the town's entry in the series *Britain in Old Photographs*, as well as editing, among others, the diaries of Thomas Bunn, published as *The Experiences of a Nineteenth Century Gentleman*. His obituary appeared in Volume 18 of the FSLS yearbook. Anything by this author is worth reading, as is anything by Reading-born Rodney Goodall, who studied architecture at Oxford before coming to Frome in 1963 to join the firm of architects Vallis and Vallis. This also began a lifelong study of the town's architecture and buildings. He started his own practice in 1968 – with an office in Bath Street – and did work for English Heritage, as well as being responsible for the maintenance and preservation of many local churches. His obituary was in Volume 15 of the FSLS yearbook and his key works are *The Industries of Frome* and, unsurprisingly, *The Buildings of Frome*.

The town's most prolific historian is Michael McGarvie. 'Historians are born not made' it says on the book jacket of his overview of the town – *The Book of Frome*, first published in 1980. After moving to Frome – having read History at University College, London – there are very few aspects of the town that he has not touched upon within his writings. His publications are too numerous to list here but the aforementioned book is a good place to start and two of the authors' well-thumbed volumes of his are *Frome Through the Ages* and *Around Frome*, the town's entry in the series *Images of England*. He edited the first thirteen volumes of the FSLS yearbook.

Although Eunice Overend's published output might seem meagre, the part she played in the town's local history studies were huge. Born in Yorkshire, where her father worked in a mill, the family moved to Frome, where she attended Frome Grammar School and Exeter University. Returning to Frome, she became a supply science teacher and taught in many of the local schools. Eunice, along with Hilary Daniel, was a founder member of the **Frome Society for Local Study**, in 1958, and it was she who invited Sir Leonard Woolley to give the inaugural address. She carried out digs at Whatley Roman Villa and Egford Medieval Village, among others, and contributed articles to the FSLS yearbook over the years. Despite this strong connection with local history, Eunice Overend will always be known as the 'Badger Lady', due to her acclaimed work with this animal, and regularly appeared on BBCs *Wildlife at One*.

Her book *The Geology of Frome* should reside on the bookshelf of any self-respecting Fromie with an interest in their town's past. Her obituary appeared in the FSLS yearbook Volume 21.

Others who have contributed substantially to the town's reputation and considerably expanded the knowledge of its local history include Alastair MacLeay who, amongst other things, was editor of FSLS yearbook between No. 14 – taking over the reins from Michael McGarvie – until No. 23, as well as overseeing many of the society's prodigious number of publications; John Payne, who edited Home in Frome's *Working Memories*; Lorraine Johnson, whose books include the histories of Butler & Tanner and Town Hall; and David Adams, author of two books documenting the fallen of Frome in both the First and Second World Wars. Among more recent authors are Annette Burkitt, author of *Flesh & Bone* (about Saxon Frome); Crysse Morrison, author of 'Frome Unzipped' (a prehistoric to post-punk history); and Robin Thornes, author of *Men of Iron* (detailing Fussells of Mells); Civic Society, Frome Family History Group or Frome Library.

One last person we have to mention is Dr John Hooper Harvey who, according to his 1997 obituary in *The Independent*, was 'the greatest British historian of Gothic architecture of the 20th century; Gothic, that is, of the Middle Ages not of the nineteenth-century revival'. He lived for many years in Christchurch Street East by Portway steps. His other chief interest, according to friend Michael McGarvie, who wrote a piece in *The Somerset Standard* about him, 'was garden history in which he became a world authority and was a former president of the Garden History Society'. John Harvey came to Frome in 1975 and during the twenty-two years he was here, 'his researches [sic] added greatly to our knowledge of local history'.

Lock-ups

Like most medieval towns, Frome had stocks and a pillory, located in Market Place, and used on those miscreants who broke the law and underwent their penance in public view. Add to this the rotten vegetation thrown at them, especially on market days – possibly the least of their worries in terms of what came their way – and one would think them a pretty good deterrent, as well as a popular, entertaining, and effective form of justice.

For those still awaiting judgement in the late eighteenth and early nineteenth centuries Frome had two 'lock-ups'. The first was an underground stone vaulted building which today still lies within the south-east corner of St John's churchyard. This 'blind-house' could hold up to two separate prisoners and although there were no windows – hence the name – the easily accessible roof possessed a tiny hatch where family (or friends) could lower food or drink to their incarcerated loved ones.

The blind-house remained the only gaol in the town until the 1720s when, during restoration of the Blue House, a more central guardhouse was built abutting the Blue

Boar Inn. Its location was chosen for its convenience to the Magistrates' Court at the end of nearby Edgell's Lane (which is now **Justice Lane** and part of the **Cheese & Grain** car park). When Isaac Gregory was Chief Constable of Frome in the 1810s, he kept a journal which contains many references to the guardhouse and the scoundrels he locked up there. These included two boys confined for 'a few minutes' for stealing money from their parents, while an older boy received an hour-long confinement for 'being impudent to me'. If their crime was more serious though, the occupant would be escorted to Shepton Mallet, 12 miles away, and then brought back again when their time came to stand in front of the local magistrate.

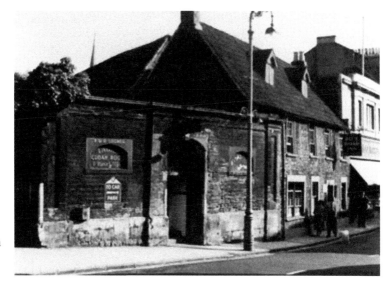

The Guardhouse in the 1960s shortly before demolition.

The Blindhouse *c.* 1798 in St John's churchyard.

After Frome gained its own police force in 1856, a purpose-built **Police Station**, with cells and magistrates' court, made the blind-house and guardhouse redundant. In the decades after, the latter acquired many uses, including a storehouse and a ladies' public convenience, before being demolished in the 1960s. As for the former, it was once restored by Frome Civic Society to something of its former 'glory', but at the time of writing remains for all to see in the far corner of St John's churchyard in a dilapidated and litter-strewn state – which is a point of shame, given its Grade II listed building status and heritage.

Loos

Frome loos have suffered a significant loss over the past few years, with at least seven being decommissioned or demolished in recent memory to provide parking spaces … or just empty spaces! There is apparently no obligation upon local councils to provide such facilities. To counteract this, the Market Yard is home to an excellent state-of-the-art convenience, catering for short or long stays, and even has piped music. There is also Frome Town Council's 'You're Welcome' Community Toilet Scheme, which offers public access to clean, safe and in most cases, accessible toilets in convenient locations across the town, with participating businesses having agreed to let the public use their facilities during normal opening hours without the need to spend any pennies. A list of those taking part appears on the council's website and includes the **Cheese & Grain**, George Hotel and Moo & Too, as well as the **Town Hall**. On an international level, there is the 'Toilet Twinning' initiative which sees two British charities raising funds for toilets in countries where there are few – or none. Several of the community scheme toilets in Frome are twinned with those in Uganda, Cambodia and Ghana. And, finally, there is the former toilet block that stands a short distance from the Black Swan Arts Centre, and near the aforementioned Market Yard facilities. To some it might give the impression of being a vandalised shipping container, but it has found a new lease of life as Loop de Loop and presents a glimpse into Frome's unique personality. The block has been converted into several small units, each reflecting an aspect of the town's character. First, there is Lungi Babas, possibly the smallest takeaway in the country. It specialises in South Indian vegetarian dishes and in the summer, there are tables and chairs outside and sometimes even impromptu events. Alongside this is the Frome Community Fridge, a clever scheme to reduce food waste. Anyone can leave food there, while anyone else can help themselves to the contents. The scheme has grown internationally and has proved a huge success. Next door again is the Frome Coat Rack, where people leave their surplus wearing apparel and, if desired, pick up something different. So here's hoping all these loos-related activities continue to be flushed with success and not go down the pan.

M

Market Place

The Market Place has, for centuries, been the centre of the town and was once divided into two halves – upper and lower – with a pub and two shops in between. These buildings jutted out from King Street and stopped within a few feet of the entrance to the George Inn, making the whole centre cramped, dirty and dingy, especially during market days.

The weekly street market in Frome was well established by the Domesday survey of 1086 and has been held ever since, although today it is much reduced and is little more than a large bread and cheese stall in the car park. The Market Place itself has the busy B3090 running through it and has little to offer apart from banks, high street retailers or charity shops, with Frome's main business taking place either within the vibrant streets that lead off from it – Stony, Bath, Cheap and King – in all their varied and independent glory, or the supermarkets on the outskirts. One attraction it does have though is the Boyle Cross. Occupying a central position at the end of Cheap Street, it was a gift to the town from the Revd Richard Boyle in 1871, to mark his family's long association with Frome. It was carved from a single block of Devon marble and stands 9 feet tall. Sadly this type of stone is rather soft, and a lot of detail has been lost. In the 1960s the council turned the bowl into a flower bed, while in 1997

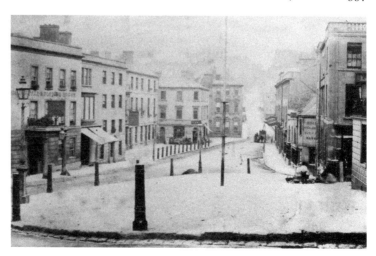

Market Place in 1865 – the oldest known photograph.

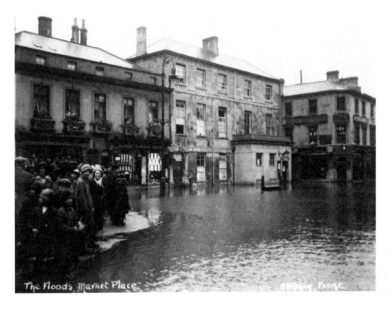

The Market Place during the flood of 1917.

it was smashed into more than fifty pieces by vandals. Fortunately, restoration was possible, and it was lowered back into position in the same year. In 2018, the water fountain was also restored, and the surrounding area paved for pedestrian use only.

Memorial Theatre

Frome Memorial Theatre opened in 1925, as a hall in memory of those who fell in the First World War. During the 1930s seating was installed to accommodate audiences for the ever-increasing popularity of cinema and for the next half century it traded as The Grand. These days, the theatre, while still a working venue, has the responsibility

Memorial Theatre, November 2018 – 100 years after the end of hostilities.

Sgt Charlie Robbins on guard at the Memorial Theatre.

of being Frome's official War Memorial, for those killed in both World Wars and subsequent conflicts. Each November the Remembrance Service is held outside the theatre, while the statue of Sergeant Charlie Robbins overlooks proceedings. Before the First World War he had worked for **J. W. Singer** and having survived the conflict, returned to his old employer, where he was chosen as the model for one of the many war memorials the firm were commissioned to make. Cast but never collected, the statue was put away until rediscovered in a back room during the 1970s and set in pride of place outside the factory, first at Waterloo and then up on the Marston Trading Estate. After much negotiation, 'Charlie' was transferred from outside Tyco's offices (the present-day incarnation of Singer's) to take centre stage at the Memorial Theatre just in time for the centenary of the start of the 1914–18 war.

Monmouth Rebellion

James Scott, the Duke of Monmouth, was the illegitimate son of Charles II but claimed to be the rightful heir to the English throne. After the death of Charles II, in 1685, he landed at Lyme Regis with the intention of overthrowing his uncle, the newly crowned King James II. He marched north into Somerset to rouse support and at its peak it was said his 'army' consisted of around 7,000 rebels. However, by the time a rain-sodden Monmouth and his men arrived in Frome, on 28 June 1685, the tide had begun to turn. A declaration an advance party had posted in the town declaring Monmouth the rightful king had been torn down and the main instigators arrested. Then, while staying in Cork Street, Monmouth learnt a simultaneous rebellion in Scotland had been defeated and royal forces were massing in Trowbridge. And worse was to come. The following day James II issued a pardon for all who had taken up arms, and so

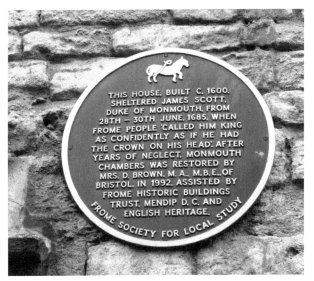

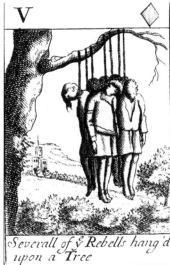

Severall of ẏ Rebells hang'd upon a Tree

Above left: Cork Street plaque records Monmouth's visit of 1685.

Above right: Contemporary playing card records the fate of the rebels.

many rebels took the opportunity to return home. A war council was hastily called and against Monmouth's belief that he should now return into exile, he was forcibly told by his generals he must fight on.

Monmouth and what were left of his rapidly dispersing army then left Frome on 30 June 1685 and headed west, towards his destiny at the Battle of Sedgemoor. Within a little over a fortnight of leaving Frome he would be dead, having been defeated, found guilty of treason and then executed on London's Tower Hill. After Monmouth left Frome, royal troops entered the town and completely 'plundered' it, although this was only the start of the retribution. At the subsequent trials – known as the Bloody Assizes – fifty Frome men were tried and found guilty of treason, being either executed or transported for life. While back in Frome, twelve rebels found guilty at the Assizes were hung at Gibbet Hill, then drawn and quartered, and their remains being strung up for all to see at **Gorehedge**. The full story of Monmouth's stay in the town can be found in our book *Foul Deeds and Suspicious Deaths in and Around Frome*.

Montgomery, Field Marshall

In June 1968, Frome welcomed back a bona fide war hero, who had last visited the town during the darkest days of the Second World War. The return visit of Field Marshall Viscount Montgomery, victor of El Alamein, was as guest of honour at a luncheon given by Frome printers **Butler & Tanner**. The occasion was the publication of his book *A History of Warfare*. A tour of the firm's printing works at Adderwell

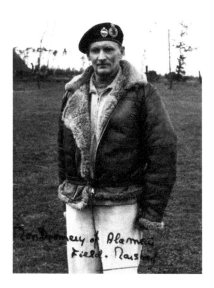

Field Marshal Montgomery 1887–1976.

was conducted before the acclaimed warrior was taken to the Portway Hotel for the honorary luncheon. During the event Montgomery was presented with a hand-tooled copy of the new book by Butler and Tanner's managing director, Mr Joseph R. Tanner.

The choice of venue – the Portway Hotel – no doubt stirred up potent memories for the Field Marshall, as this had been his temporary headquarters twenty-eight years earlier. The story began with Dunkirk, in May 1940, when the British Expeditionary Force, which included Montgomery's 3rd Division, had been evacuated to England. Once back on British soil, his battered and scattered division was to reform in Frome and he installed his headquarters at the Portway Hotel. The Portway had been built as a residential house around 1800 but had been converted into a hotel in 1934, six years before the War Office and Montgomery requisitioned it.

Although still functioning as a hotel in 1968 – during Montgomery's return visit – the Portway closed in the late 1980s and is today retirement flats. Back in 1940, and before the re-equipped 3rd Division could head back across the Channel, France fell, and Montgomery and his men were reassigned to the south coast. Once there, the Major-General, as he was ranked at that time, began to prepare the coastal defences against an expected German invasion.

A plaque to commemorate Montgomery's brief tenure in Frome, in 1940, however, along with his wider war contribution, was unveiled in May 1947 on the Portway's outside wall. It was designed by H. E. Stanton, a former headmaster of the Frome School of Art and Science, and was made by Frome Art Metal Workers Guild.

Museum

Frome Museum is near the centre of town, at the bottom of North Parade, in a listed building dating from 1869 and built for Frome Literary and Scientific Institution.

There are two galleries containing fascinating collections of local, regional and even national importance which have regularly changing exhibitions and displays of a wide range of local history. There is a small selection of books for sale, while its library cum archive is open to researchers by appointment throughout the year – (but please note anyone wishing to use these resources are asked to email, telephone or write to the museum to arrange an appointment and give brief details of their research requirements, as this will allow the volunteers to locate relevant documents and photographs in advance of their visit). In line with policy at most archives, a small charge is made for photocopies and other services. Details are available on request. The museum is run entirely by volunteers and receives no support from local authorities. Admission is free although a donation is welcome and the amount of £2 suggested. The museum is always very grateful for donations of material relating to the history of Frome and surrounding parishes, but again, please contact in advance so appropriate arrangements can be made for your visit. The museum is open from mid-March until mid-November and from Tuesday to Saturday, 10 a.m. to 2 p.m.

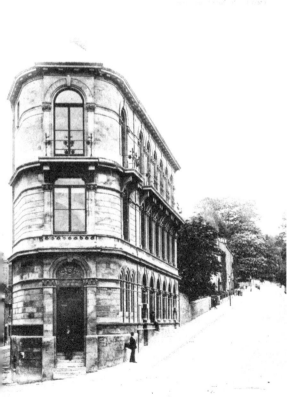

Above left: Frome Museum in 1904.

Above right: Pub memorabilia at Frome Museum.

N

North Hill House

Erected in the 1770s by mercer Timothy Lacey, who married into the Sheppard family of clothiers, it was at one time home to Philip Le Gros, the silk manufacturer, and then later to the Wickham family, who moved there in 1800. It was greatly remodelled in the nineteenth century and was used as offices by the Frome Urban District Council. Since September 1999, the building has been home to an independent specialist school and part of the Priory Healthcare Group.

During the summer of 1931 workmen were engaged in widening the road on the small triangle of land at the top of North Parade, where Fromefield and Berkeley Road divide, and not far from North Hill House. At the depth of around 2 feet they came across a human skeleton fully stretched out and buried face down. Although it was originally thought to be a Roman burial, it seems more likely to have been a much later suicide, who was the posthumous victim of a tradition which forbade burial in consecrated ground – hence its rather undignified final resting place.

North Hill House, 1763, but much altered.

Oatley, Sir Charles (1904–96)

Sir Charles William Oatley OBE, FRS FREng was Professor of Electrical Engineering at the University of Cambridge between 1960 and 1971 and was responsible for having developed one of the first commercial scanning electron microscopes, along with being a founder member of the Royal Academy of Engineering. He was born in Frome on Valentine's Day 1904, at No. 5 Badcox, where his family ran Oatley's bakery. He was educated at the Council School in Milk Street and went on to study at St John's College, Cambridge. During the Second World War he was engaged in important research and his work was a major contribution to the development of radar technologies in the conflict. He died in 1996. A plaque marks his birthplace at No. 5 Badcox, which today is still home to a bakery.

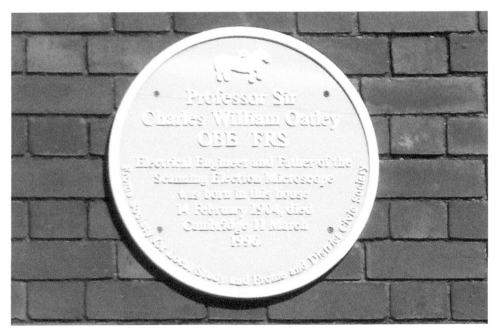

Plaque to Sir Charles Oatley, No. 5 Badcox.

P

Police Station

Once upon a time, Frome had a reputation for rioting and civil disobedience, and it is no surprise that as soon as Somerset gained its own constabulary in 1856, a detachment was sent with great speed to be based in the town. Initially housed in the old Eagle pub, on the corner of King Street and Eagle Lane, this was a temporary measure and in the following year, 1857, they moved to a large Gothic Revival building designed by Charles Davis of Bath. It sat high up on a grassy slope in Christchurch Street West – or Behind Town – and incorporated a magistrates' court, prison cells and living quarters. In the 1861 census, the latter was shown to be occupied by Superintendent Edward Deggan,

A Frome constable in the station yard. (Frome Reclamation)

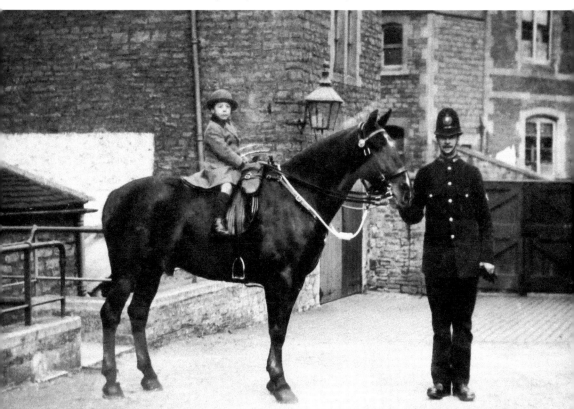

Frome Police Station and Court from 1857.

a thirty-two-year-old married man from Gloucestershire, his wife, their daughter and an eighteen-year-old domestic servant named Sarah. Also included in the census, but no doubt residing elsewhere in the building, were five police officers, all in their twenties, and three prisoners (the occupations of these being recorded as a butcher and two labourers). The building served its purpose until 1952, when the police force moved to Oakfield Road. At the time of writing Frome Police Station is situated above a takeaway with an information desk in the town library. The original building in Christchurch Street West is currently home to a dance school.

Pubs

There have been so many pubs in Frome over the preceding centuries that one could write an entire book about them – and someone has. The Archangel, Artisan, Blue Boar, George Hotel, Griffin, **Lamb & Fountain**, Old Bath Arms, Sun, Three Swans, and The Crown in Keyford are just some of the town's pubs that have an historic pedigree and are still serving today. For more details about these, as well as numerous others, past and present, the reader is directed gently towards *The Historic Inns of Frome*, which just so happens to have been co-written by one of the authors of this book.

Above: The Blue Boar pub, 1691.

Below left: The Archangel pub, King Street, early eighteenth century.

Below right: The Archangel passageway which divides the pub in half.

Quakers

The Quakers were just one of the many nonconformist groups in Frome but seem to have been first to build a specific place of worship in the town. This religious group was founded in the north-west of England by George Fox and was officially known as the Society of Friends. The original converts to this form of dissenting – who became known as the 'Valiant Sixty' – set out to spread the word across the rest of the country. The name 'Quaker' itself was first used as a term of ridicule but stuck and has been used ever since.

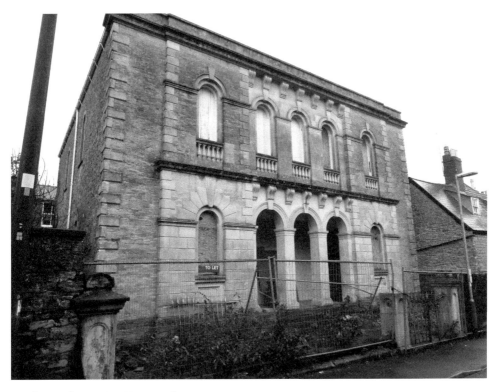

South Parade Meeting House today.

Quakerism began in Frome in the mid to late 1650s and the first person to 'receive the truth' in the town is recorded as being one John Clare. By 1668 there was at least six members and they secured the patronage of John Sheppard, a member of the locally famous clothier family who allowed them to establish a meeting house and burial ground on his land. This was in 1675 at the top of what is now South Parade. This seems to have been quite a gamble by Sheppard, as the Conventicle Act of 1664, which forbade religious gatherings outside the parish church for more than five people, was still in force. It was not until the ascension of William of Orange, after the Glorious Revolution, that the Act of Toleration (1689) came into being and religious worship other than that within the authorised Church of England was allowed. Although Frome became a major town for nonconformists, the Quakers' existence fluctuated. The original meeting house was replaced in 1783 but had to be leased out to other organisations and groups to cover costs. Sometime in the mid-1850s this was the YMCA, while later, according to Rodney Goodall's authoritative *Buildings of Frome*, it was doubling up as a private Girls' School. In 1933, it became the county library for Frome, but was sold to the British Red Cross in the 1950s. It is now residential dwellings.

Railway Station

Plans for Frome to be linked to Weymouth were approved in 1845, with Frome Railway Station being opened on 7 October 1850. It was designed by T. R. Hannaford, one of Brunel's team, and the original plans are still stashed away at Paddington Station. It

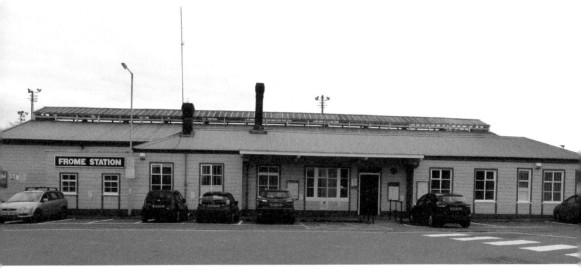

Above: Frome Railway Station *c.* 1850.

Left: The station interior in 2019.

is a unique survivor of the passenger shed style with a timber frame and corrugated-iron roof. It has been restored on a few occasions, but it is sadly underused with only one platform and the toilets long out of use.

Rook Lane Chapel

When Vicar John Humphry lost the living of Frome, for refusing to revert to the Book of Common Prayer, he and many of his congregation left St John's Church and headed up to what was then known as Behind Town, to continue their worship. In 1707, after the Act of Toleration (1689) made nonconformist worship legal, Rook Lane Chapel was built by James Pope and heralded as one of the finest nonconformist chapels in the west of England. According to Rodney Goodall, 'The original building was a plain rectangle of 7 bays by 5 bays, with internal dimensions of 18m × 12m (60ft × 40ft).' Internally there were two Tuscan columns, which supported a three-sectioned ceiling, of which the centre section was a domed vault that gave the church a local nickname, 'The Cupola'. There were staircases on either side and these led to a gallery which extended around three sides; the building, lantern-like, was lit by semicircular arched windows at both levels on three sides.

Although the congregation continued there for the next two and half centuries, there were dissenters even within their own ranks and in 1773, several members broke away and established their own church, **Zion Chapel**, in Whittox Lane. Two centuries later with both of the congregations experiencing decreased attendance,

Rook Lane Chapel, 1707.

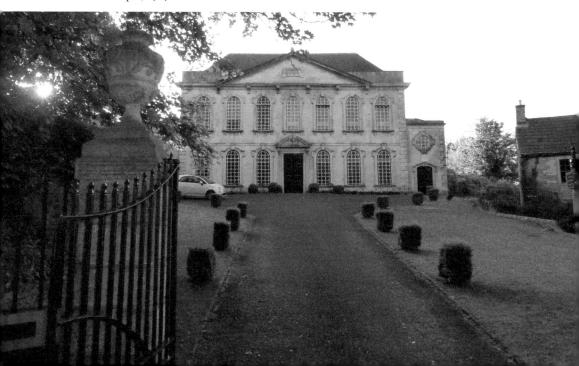

they joined back up under the banner of Frome Congregational Church (and later United Reform Church). As Zion Chapel had more space, it was decided to abandon Rook Lane Chapel to its fate – or rather various developers over the coming years. For a long time, as it became more dilapidated, decayed and vandalised, it seemed that it might be converted into flats or even demolished. A campaign to save the building was launched, and it was purchased by Mendip County Council. After a major renovation, it became home to NVB Architects, who run it as a versatile arts centre for exhibitions, weddings and performances. Today, Rook Lane Chapel is one of only two Grade I listed buildings in Frome – the other being the **Blue House** – and is seen as being the finest example of this type of nonconformist chapel in the entire country.

Rook Lane House

This stunning house in Christchurch Street West was built in 1604 for the Smith family of clothiers and has been much altered to adapt to changing tastes through the years with the bay window having been added in Victorian times along with many internal alterations. It was once the home of Elizabeth Singer Rowe (1674–1737), now seen as a sentimental 'devotional poet' and nonconformist, but much read and admired in her time. The building is now a high-end B&B.

Rook Lane House.

Round Tower

Frome was famous not only for its wool and being one of the main centres of cloth production during medieval times, but for the quality of its blue dye derived from the Woad plant that thrived locally. This eighteenth-century round tower, now part of the Black Swan Arts Centre, off Bridge Street, was associated with the dye works of the post-medieval period which often took the form of circular stone towers. The woollen cloth, after being soaked in dye, was hung up in lengths from wooden beams to dry after dipping, with a carefully controlled fire being lit in a stove at the base of the tower to speed up the process. Such drying houses represented an advance on the medieval wooden drying racks which were set in open areas and relied on the wind and sun. The one in Frome has been converted for housing small exhibitions and is one of only two surviving in the town, the other, now near derelict, being at the Coach House in Willow Vale.

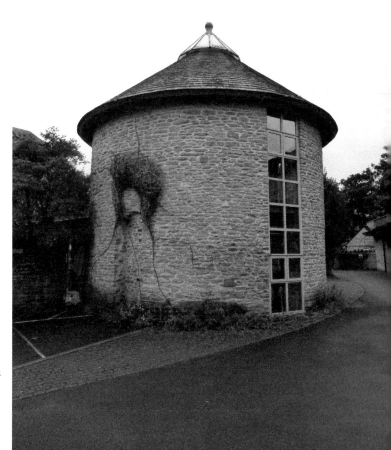

The round Drying Tower in Justice Lane.

SHARE: A Library of Things

There are numerous instances of initiatives and schemes which exemplify what exactly it is that makes Frome a special place, full of community spirit, compassion, enterprise and inventiveness, and SHARE is one of them. By allowing residents to borrow, for a minimal fee, good-quality household and leisure items donated by the public, SHARE aims to save people money and reduce waste. The scheme gives the young people who created it free, intensive training in community entrepreneurship.

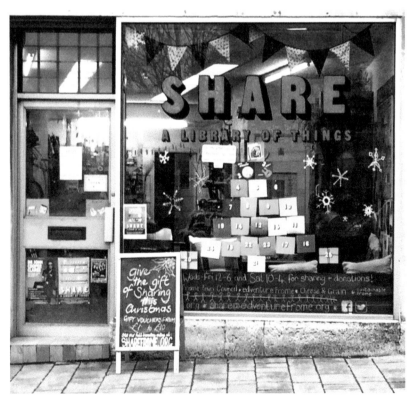

SHARE: A Library of Things.

Singer's

John Webb (J. W.) Singer was born in 1819 in Frome and spent his formative years at the Butts where, as a youth, he watched the goings-on at a nearby foundry with enthusiasm. He tried his hand at casting toy cannons but after leaving school he undertook an apprenticeship with a local watchmaker and on its completion, went to work in London. He later returned to manage the business with which he had completed his training and began making brass ornaments for local churches encouraged by the town's recently appointed vicar, Revd William Bennett. The rise of the Oxford movement, with Bennett at its forefront, sought to reinstate older Christian traditions and thus created a huge demand for his services. Legend has it that Singer cast his first brass altar candlesticks using turnips as moulds! Eventually he gave up watchmaking and established an art metalwork foundry, which soon became one of the most respected in the country.

During the final year of the nineteenth century the firm became a limited company and by now had become internationally known for its bronze statues, which would include such iconic statues as *Boudica and Her Daughters*, which stands on the Thames Embankment, *Justitia* at the Old Bailey, and Winchester's *Alfred the Great*. When a new bronze statue was ready to leave the factory, it is said the town's entire population would turn out for its journey to the railway station and from here, the firm's work was exported worldwide, to countries that included Australia, India, South Africa and New Zealand.

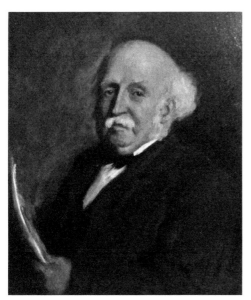

Above left: J. W. Singer 1819–1904. (Frome Museum)

Above right: Singer's *Justitia* gets a clean at the Old Bailey.

The town celebrated the 200th Anniversary of J. W. Singer's birth in 2019, with Sue Bucklow at the helm, through a year-long feast of events, a book, and the creation of the Singer's trail, taking in many of the sights and sites associated with this most famous of local firms.

Singer's factory at work.

T

Town Hall

Frome's Town Hall is a little way from the centre of things, being in Christchurch Street West, but manages to keep its finger on the pulse. It was built in 1892, by Joseph Bird of Radstock, in the fashionable Italianate style using native stone from the Butts. Although its railings went in the Second World War and it also lost its tall chimneys, it is otherwise unchanged. Its original purpose was to house the offices of the Poor Law Union – the Frome Guardians – but it soon also became home to the newly formed FUDC (Frome Urban District Council). In 1974, after another national reorganisation of local government, it was considered surplus to requirements and subsequently 'sold' to Somerset County Council for a nominal £1. Forty years later, in 2014, it was offered back to Frome Town Council for £325,000. This sparked a protest in the town under the moniker 'Give Frome Back Its Building', which attracted much local support and media interest. Eventually a sale was agreed between the two councils for £275,000 – a £50,000 reduction – and today, after a wonderful internal restoration project by NVB Architects, it is home not only to the Frome Town Council, but also a host of community and volunteer groups. For a history of this building, see Lorraine Johnson's 2017 book *Frome Town Hall*.

Frome Town Hall, 1906.

Trinity Slum Clearances

It may seem unbelievable today, but at one time local authorities thought nothing of demolishing huge swathes of historic buildings and landmarks in the name of progress. During the 1960s and early 1970s an orchestrated programme of slum clearances wrought havoc throughout towns up and down the country and Frome was no exception. The most affected area in Frome was at Trinity, which consisted of street after street of residential housing that dated from the town's cloth trade heyday. It was in the 1950s that Frome Urban District Council designated Trinity as a housing Clearance Area which was 'ripe for development'. Thankfully, in retrospect, it was decided to undertake this act of historic vandalism in stages.

In 1960, the government approved a Compulsory Purchase Order (CPO) that paved the way for the demolition that would be undertaken within Phase One – the area bounded by Selwood Road (which was to be realigned), Milk Street, Castle Street and Trinity Street. Among the places consigned to history included Broad Street and Bell Lane – site of **Cockey's** original bell foundry. By 1967, the area in Phase One had been rebuilt and the following year another CPO allowed Phase Two to proceed, which concentrated on the north-east region. This time around, those places lost to the bulldozer included Peter Street, Rosemary Lane and Duke Street.

Frontispiece The Trinity area in 1925. This is the only photographic record of many of the houses since demolished. *Reproduced courtesy Aerofilms Limited.*

Trinity from the air in 1925. (Aerofilms)

A house in Trinity in 1977.

Before Phase Two was completed public feeling towards this wholesale destruction of the past attracted the attention of conservationists, and by the time Phase Three was ready to progress, the 'Save Trinity' campaign was well and truly underway and the fight to reclaim the town's history established. What helped to a large degree was the realisation that the housing in Trinity was much older than initially thought and now also unique.

The Trinity area had been built between the late 1660s and the 1720s, at the height of Frome's prosperity through its cloth industry, to house its many workers and those of related industries. Other places with equivalent areas – such as London and Manchester – had long seen their houses demolished when investment had sought to rejuvenate them. But because Frome had missed out on any similar investment for such a long time, these houses had remained intact, albeit in an increasingly dilapidated state. With its historic value now understood, demolition plans were reversed, and restoration became the order of the day. Which was just as well, as Trinity is now recognised as the earliest remaining large area of industrial workers' housing in the whole of Britain. Thankfully, the houses 'saved' within Phase Three comprised the oldest part of the area – including Vallis Way and Castle Street (originally known as Long Row) – and of the greatest historic significance.

To fully appreciate the work and effort of the conservationists and restorers take a stroll down Trinity Street, Castle Street, Naish's Street, along with the little street leading off them and admire the homely beauty that remains.

Tunnels

Rumours of a large network of secret tunnels under Frome have been around for decades and many tales were told of prolonged walks down these passages years ago. Tunnels from Frome to Nunney, Frome to Longleat and another from Welshmill to Beckington were said to exist despite the overwhelming impracticality of such major engineering projects. Many others were claimed to lie underneath the town streets and were much discussed in the 1960s when a fine set of medieval drains were uncovered at the top of Catherine Street.

The Frome Society for Local Study carried out a brief excavation with local schoolboys at the Old Church House, near the churchyard, with some encouraging results, but had to stop at a certain depth as they were unable to shore up the sides, so as to dig deeper, in the time available. Another investigation discovered steps leading down to a stream under a shop in Cheap Street, and the society drew up a large-scale map of the tunnels that it had been told about.

More recently investigations by the Frome Tunnels Group have uncovered fascinating underground features, including industrial flues connected to the wool dyeing trade, wells, drains to channel water from many springs in the area, vaults and even an ancient ice house underneath the **Lamb & Fountain**, in Castle Street. Despite much enthusiasm and a host of blocked entrances, the fabled tunnels are still yet to appear; work, however, continues ...

Blocked cellar entrance at the Griffin.

U

UFOs

In January 1978 the Portway Hotel in Frome was subject to an 'unearthly experience' when it hosted an event on Unidentified Flying Objects. Visitors to this one-day exhibition were able to see pictures supplied by the 'UFO Info Exchange at Trowbridge', among other exhibits, and witness the first showing of colour slides of what were claimed to be UFOs taken by the Apollo astronauts. The event was just one of several promotional happenings timed to coincide with the publication of the local tourist brochure 'Frome is Flying Saucer Land'.

The origins of what was to become first a local and then a national sensation lay back in 1961 when residents of Warminster began hearing 'strange noises' that seemed to come from the sky. This was followed by four eye-witnesses who claimed to have seen an object shoot across the heavens, leaving a 'trail of sparks', and, over subsequent months, other strange aerial events were reported in the area. These soon reached the attention of the national press and these occurrences became known collectively as the Warminster 'Thing'. Along with those 'incidents', there were accounts of pigeons having dropped from the sky, dormice and partridges on the ground stunned, car engines having stopped, and cattle having stampeded.

At the age of twelve, one of the authors of this book managed to persuade his elderly grandfather to drive from the other side of Bristol and climb to the top of nearby Cley Hill, where they spent the afternoon with an assortment of photographers, tourists

Cley Hill – scene of many UFO sitings in the 1960s.

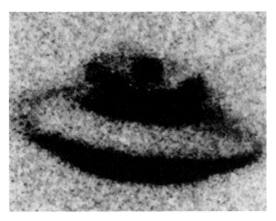

The Warminster Thing.

and 'spiritual people', all of whom were waiting for aliens to make contact. Sadly, at least on that day, they failed to do so.

Whatever one might think of this phenomenon, there were certainly several very strange occurrences along the Somerset and Wiltshire border in the mid-1960s, many of which remain unexplained to this day.

Unicorn

This single-horned horse-like beast is seldom seen at all these days though there is the mounted head of one amongst the eclectic memorabilia of Chris Moss at the Three Swans in King Street. It is believed that he brought it back from a trip to Narnia as a boy.

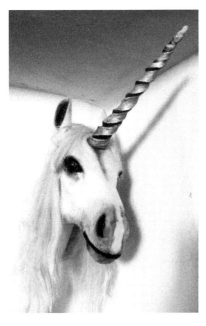

Unicorn head at the Three Swans.

V

Valentine Lamp

This brightly decorated cast-iron column lamp stands at the top of Catherine Street and dates from around 1890. It was restored and erected by local man Reg Ling in 1993 as a tribute to St Valentine and lovers everywhere. It is the only surviving gas light in Frome and subject to a ceremonial lighting on 14 February – Valentine's Day – every year. Attached to it is a small but original George V rural-style posting box that is marked for 'letters only'.

Vinegar Works

There must be few small towns that can boast their very own vinegar factory, but Frome was one of them. It has been very little researched, yet it was certainly going in 1873, when the partnership between James Oxley and James Richmond was dissolved. Presumably Richmond carried on by himself, as in 1888 the factory was put up for sale by its operators Richmond & Co. The works produced its brew from a large stone building near the Welshmill end of Park Hill Drive, then known as 'Lady Mary Spring Lane'. It was a large operation and so their product might well have been sprinkled on chips far and wide throughout the land. Soon after the Second World War ended the business was purchased by British Vinegars Ltd, due to their main place of operations in Bristol having been destroyed during the bombing of the city. Along with the existing premises they acquired nearby land, with the intention of extending the whole operational base nearly ten-fold. Sadly, they had not considered the necessary planning permission and despite the backing of Frome Urban District Council, this was refused on the grounds the area was better suited to residential development, and this was what happened; the first results, in 1958, were houses on what was named Park Hill Drive. As for the vinegar works, this later became a depot for another flourishing local industry, Benchairs, who imported parts of bentwood chairs from Eastern Europe to assemble and distribute from Frome. In 1970, the building was engulfed in flames and an estimated £35,000 worth

The Vinegar Works in 2019.

of damage was done. The firm moved to North Wales in 1991. Today, the premises are home to a variety of local enterprises and initiatives, including the 'Men's Shed', a bicycle workshop, upholsterers, photographic studio, stationary designer and a bookkeeper.

W

Woollen Cloth Industry

Frome was important as a cloth manufacturing and trading centre for more than three centuries and its prosperity and wealth rose and fell with that of the woollen industry, not only locally but also elsewhere within the West Country. Its importance to the town as a source of employment was not far behind that of agriculture and associated crafts.

The process of cloth production involved several stages such as scouring, washing, drying, dyeing and carding. These tasks were initially carried out by skilled artisans, although later they were completed by machine. When Defoe wrote about the town in the early eighteenth century, he remarked that quite possibly, with its wealth and continued expansion, Frome could become the greatest inland town in the whole country. Due to various circumstances, and the clothier family's apathy to new technologies, when Cobbett came through on one of his rural rides a century later, the bubble had burst, and dire poverty was about the only thing he found here.

There would be slight recoveries now and then in the coming century, but for the most part Frome's prosperity and renewed status would come from non-related industries, with companies such as **Butler & Tanner, Cockey's and Singer's**. Nevertheless, the last mill continued until 1965.

Workhouse

The Frome Workhouse was built in 1838 to comply with the terms of the Poor Law Amendment Act of 1834. The aims of these workhouses were to reduce the cost of looking after the poor, remove beggars off the streets and provide a harsh and unpleasant regime that would encourage poor people to work hard to support themselves rather than seek relief within its cold stone walls. Situated on the south side of Weymouth Road, it was designed to hold 350 people and cost £5,400 to build. It was built on a hexagonal or 'Y' plan, with an entrance and administration block to the east, along with a central hub from which radiated three accommodation ranges, with exercise yards for various classes of inmate. The building later became Selwood Hospital, and much of it can still be seen today, although now converted into flats.

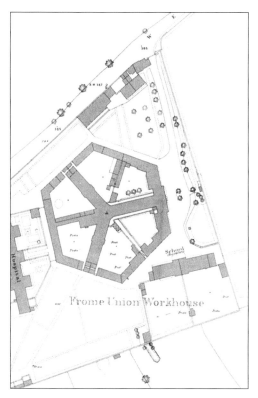

Left: Frome Workhouse, 1886. Ordnance Survey.

Below: The tramps' quarters, Frome Workhouse.

X

Xmas Lights 2013

For the thousands of local people who attended the turning on of Frome's Christmas lights in 2013, it was an experience unlikely ever to be repeated or forgotten. For this was the year that one of the town's most famous sons – Formula One World Champion Jenson Button – returned to do the honours. But this was no ordinary homecoming. The Grand Prix team he was racing for at the time, Santander, in collaboration with the Frome Town Council, turned the **Market Place** into a racetrack for the event, so that the former Frome College schoolboy could literally burn up the tarmac seated in his Formula One car, after first having obliged with the lights. The noise was deafening, the doughnuts thrilling, and the speech delivered from the balcony of the George Hotel inspiring. Although the cost was in the region of an eye-watering £70,000, thankfully most of this was paid for by Santander.

Yerbury Family

The Yerbury family had a long association with Frome (and nearby Laverton). In 1606, the manor of St Katherine's passed into their hands. Previous to that, the manor house and most adjacent land belonged to the free chapel of St Katherine's, but in 1548, with the Reformation, the chapel was dissolved and its lands, including the manor house, were sold off to the Thynne family of Longleat. All this was passed on in 1563 to Richard West of Frome who, in turn, passed it to his son, also named Richard. At the beginning of the seventeenth century, the estate was purchased by John Yerbury of Atworth (who was West's uncle) for the sum of £400. When Yerbury died in 1614, it went to his son Richard and it was he who first developed part of the lands, which would become known as the **Trinity** area, for housing.

In later centuries, a branch of the Yerbury family ran the Frome Selwood Carriage Works at Keyford and sold both new and second-hand carriages, claiming, it was said, to have more than 100 for sale at any one time.

Z

Zion Chapel

In 1773, a breakaway congregation from **Rook Lane Chapel** established the Zion Chapel in Whittox Lane. There seems to have been an earlier place of worship on or near the site but as Rodney Goodall states in his book the *Buildings of Frome*, 'the 1801 erection of this Zion Congregational church is sometimes referred to as "a rebuilding"'. According to Goodall, the church 'received a drastic overhaul and possibly an extension, in 1888'. This later renovation was undertaken by the younger

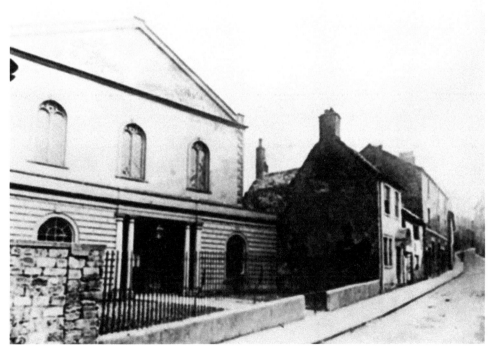

Zion Chapel, before the rebuilding of 1888.

Zion Chapel restored.

Joseph Chapman, who was also responsible for the design of Selwood Printing Works, the eclectically styled 44 Portway and the Temperance Hall, which stood in Catherine Street. For the Zion Chapel renovation, Chapman chose to employ, at least on the exterior, a distinctly Northern Italianate style, complete with ornamental gates and railing and a secondary entrance via Catherine Hill. The building is now the Rye Bakery and café.

TWENTY-TWO MONTHS UNDER FIRE